D1596506

the social food

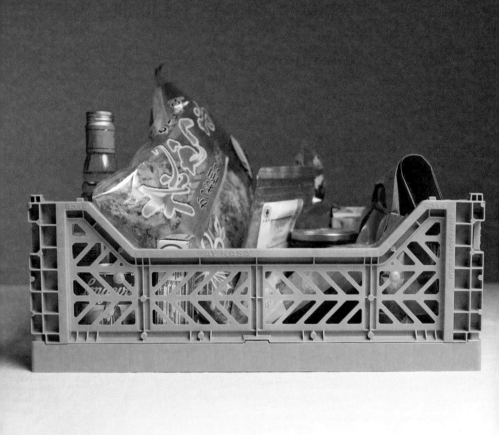

the social food
HOME COOKING INSPIRED
BY THE FLAVORS OF THE WORLD

Shirley Garrier & Mathieu Zouhairi

RIZZOLI
NEW YORK

New York · Paris · London · Milan

A true melting pot

Their suitcases of selflessness resound with the clickety-clack of vials and jars jammed in, sparing no space: trophies attesting to their recent travels. Destinations decided by a fingertip traced across a globe: There, that's where we'll go. Lands whose pronunciation can be as hard as super spicy soy sauce. Deals sealed with full wagons and a shake of the hand.

　　Where their sure footsteps lead, our noses can't help but follow. Meet at the intersection of scent and aroma. Four-footed escapades weave and glean, evidenced in their bags and boxes. A series of peregrinations, of perfectionistic packing, a veritable Tetris of treasures to make even Marie Kondo balk. A gift. Discoveries that feed their infinite ideas. Inspiration. Instinct. Instant tea. A draft of a draught. Rich spices to infuse, to diffuse. Time to think. An equation: fusion plus tradition. Family plus heritage. Fear of success. Fear of redress. Fresh pasta, out to dry. The beautiful bubbles of a rolling boil. The scritch-scratch of a pencil on a pad. A pairing idea. It grumbles; it grows. Water is wet—it's no surprise—and the night is dark and daunting. The heart races. Slows. The algorithm. The code is cracked. The saloon doors slam. Eureka. Now just cook, taste, snap until the wee hours. A blessed life of hard work. A drop of chile for a drop of sweat. No clocking-in for this assembly line. Discovery is on the menu. And Brie is just the beginning. Indian, Catalan, and Thai mix and mingle. Here comes the book, so buckle your seatbelt. Those in the know know, so here we go. Breathe in the scent of this true melting pot.

Julien Dô Lê Pham

Foreword

Table of Contents

✡ CHEZ BOB DE TUNIS ✡

VINS BOKOBSA . Spt DE CASSE CROUTES TUNISIENS . CACHER

✡ CACHER CHEZ BOB ✡

a toute heure
Boutargue - Bricks - Fricassées
Salaisons - Vin - Pistache

10, rue Richer - 75009 Paris
Tél: 01.45.23.51.79

chez Bob
de Tunis
CACHER
VIN et BOUKHA-
BOKOBSA
- Pistache
- Apiam's
- ...
- Noix de Créaux
- Boutargue sèche

chez Bob
de Tunis
CACHER
VIN et BOUKHA
BOKOBSA

Brick à l'Œuf
Cassecroûte
Plat Tunisien

A TOUTE HEURE

PLAT
TUNISIEN
BRICKS

SANDWICH
TUNISIEN
FRICASSE

SABER
REBAI

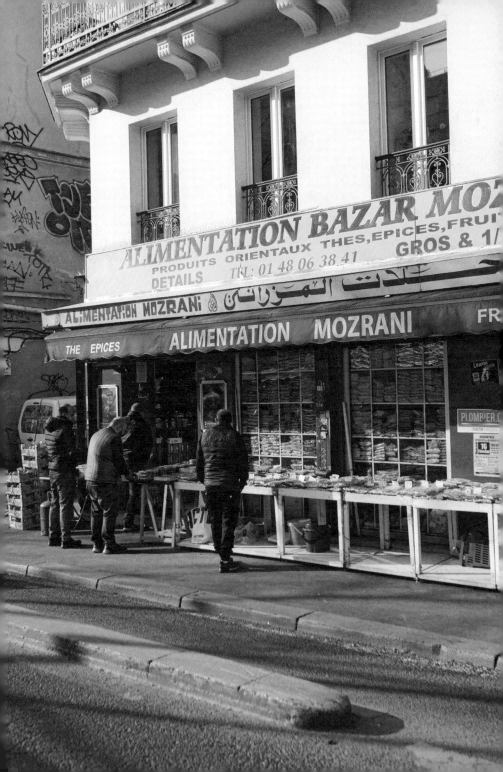

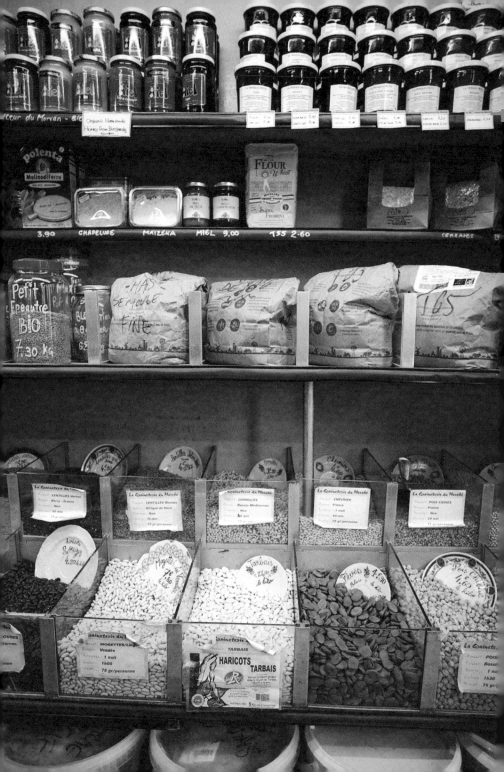

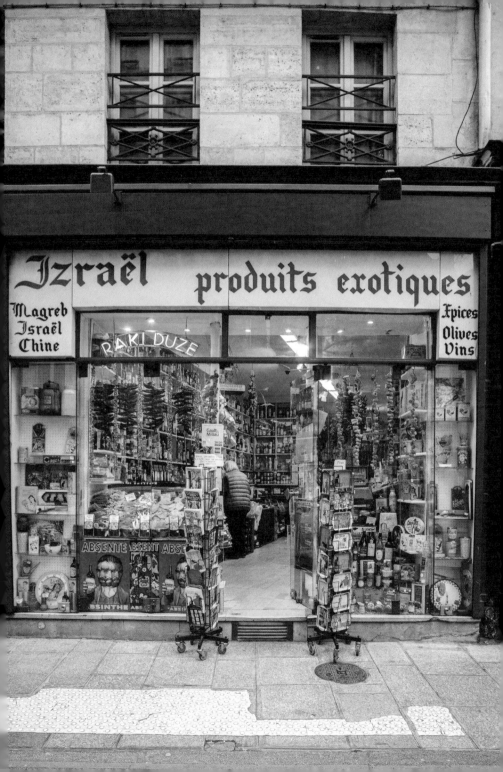

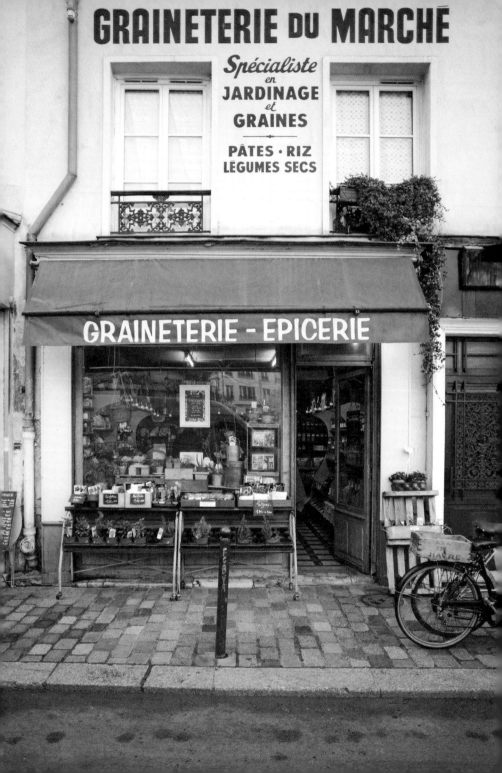

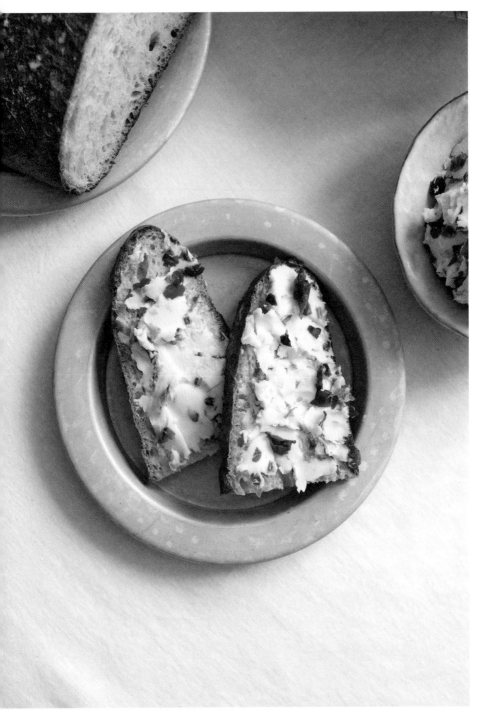

dried seaweed flakes ^{3 tablespoons}
(wakame, sea lettuce, and dulse)
raw cream ^{4 ¼ cups}
flaky sea salt ^{1 tablespoon}
(fleur de sel)

———

[1] In a mixing bowl, rehydrate the seaweed for 10 minutes in cold water. Drain.
[2] Beat the cream in a bowl until the buttermilk separates from the butter.
[3] Strain over a bowl using a cheesecloth, and squeeze to ensure all of the buttermilk is strained out. Reserve the buttermilk for another recipe (Buttermilk Fried Chicken, see recipe p. 55).
[4] Place the butter in a mixing bowl, then incorporate the seaweed and the salt, mixing with a rubber spatula. Shape the butter in the desired form then store in the fridge.

For 1 block (about 12.5 ounces) Preparation 45 min

Seaweed Butter

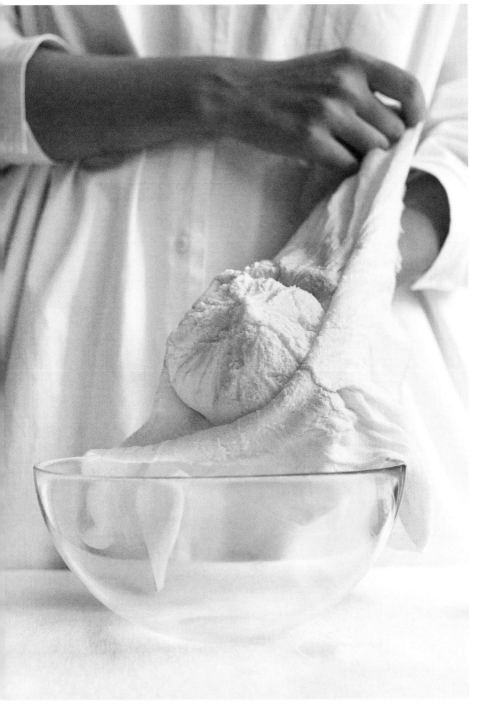

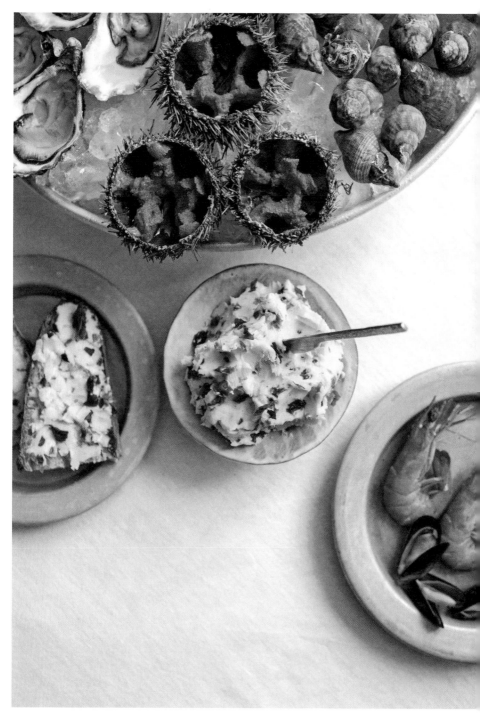

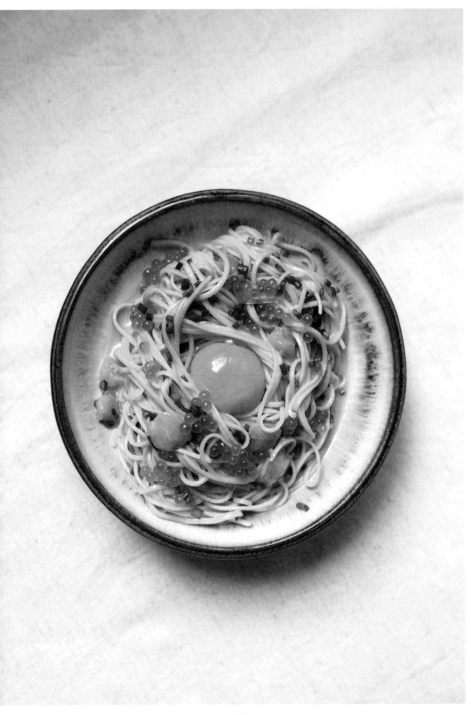

chinese noodles [7 ounces]
olive oil [2 tablespoons]
smoked salmon [7 ounces]
chicken broth [7 tablespoons]
egg yolks [4] chives [½ bunch]
soy sauce [2 tablespoons]
crème fraîche [1 tablespoon]
salted butter [2 tablespoons]
trout eggs [2 tablespoons]

[1] Bring a large pot of unsalted water to a boil. Cook the noodles for 2 to 3 minutes, then drain. Add the olive oil to the noodles to keep them from sticking.

[2] Cut the smoked salmon slices into strips.

[3] Pour the chicken broth into a frying pan, then add the noodles. Reduce the broth over low heat for 3 minutes, then remove the pan from the heat.

[4] Beat 2 egg yolks in a bowl and mince the chives. Add the soy sauce, crème fraîche, butter, beaten egg yolks, and the chives to the pan. Toss to combine.

[5] Divide the noodles on each plate. Just before serving, add half the strips of smoked salmon, half the trout eggs, and 1 raw egg yolk per person on each plate.

Serves 2 Preparation 10 min Cooking 10 min

Chinese Noodles with Smoked Salmon

clementines

clementines ³ ⁺⁵, depending on their size

coarse sea salt ³ ⁺⁵ teaspoons

[1] Cut the clementines in quarters without fully detaching them, so that they look like a flower opening.

[2] Fill the inside of each of the clementines with a teaspoon of coarse sea salt. Place in the jar, packing them down well. The juice should start to come out.

[3] Close the jar and rest 1 week at room temperature.

[4] After 1 week, if the clementines are not covered in juice, boil and then cool mineral water. Once the water has cooled, pour it into the jar to cover the clementines.

[5] Wait 3 weeks before consuming. Once opened, store in the fridge and enjoy quickly.

The fermented clementines can be enjoyed with roasted chicken, in tagines, or as a seasoning for vinaigrettes.

For 1 (17-ounce) hermetically sealed glass jar
Preparation 10 min Rest 1 month Keeps 1 year

Lacto-Fermented Clementines

whole sea bass
cleaned [1 pound 12 ounces]
egg [1] cornstarch [1 ½ cups]
frying oil

[1] Remove the head from the sea bass, and set aside.

[2] Fillet the bass. First, place the fish on its side, and make one lengthwise cut along the backbone. Then, insert the knife blade deeper, and slip it along the fillet to separate it from the bones without detaching the fillet from the tail. Do the same on the other side.

[3] Open the fish and remove the dorsal bone with kitchen shears.

[4] Set the fish so that each fillet is flush with the work surface. Slice ⅓-inch-long notches lengthwise into each fillet, then do the same widthwise (see p. 32). Do not cut all the way through to the skin.

[5] Dunk the fish in ice water, then pat dry with paper towels. Season with salt and pepper, and place the fish in a baking dish.

[6] Beat the egg in a small bowl, then pour it over the fish. Toss to coat.

[7] Pour the cornstarch into a dish and dredge the fish evenly.

[8] Heat the oil to 350°F, and fry the fish for 6 to 8 minutes. Batter, bread, and fry the head in the same fashion.

[9] Serve the fish and the head on a plate, with white rice and soy sauce, if desired.

Serves 4 Preparation 15 min Cooking 6 to 8 min

My Grandma's Fried Fish

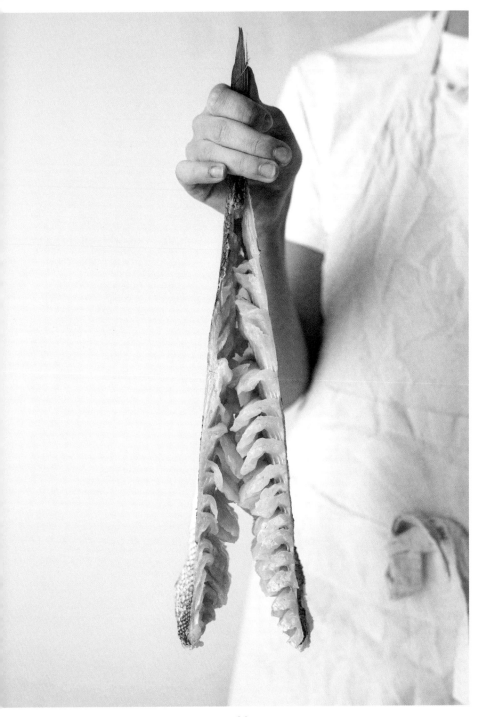

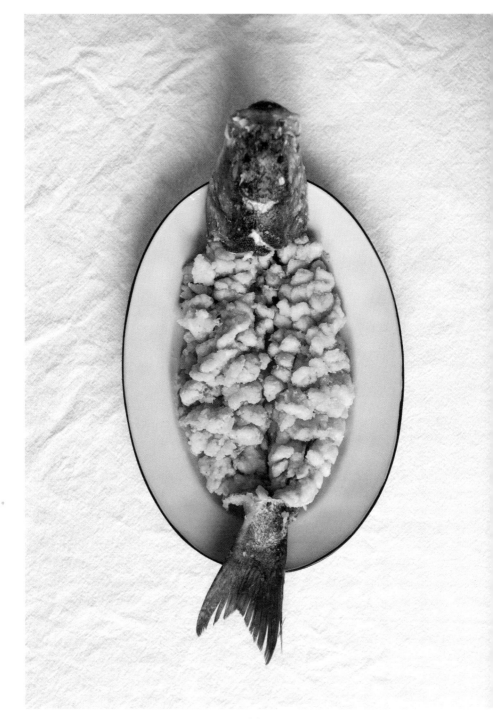

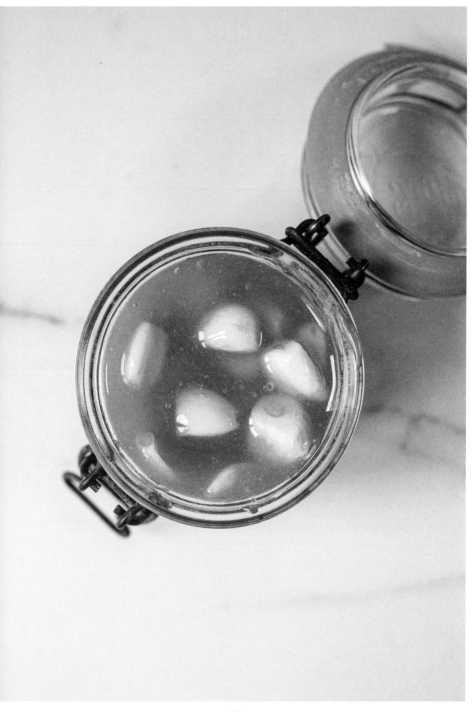

garlic 5 ⅓ ounces (about 50 cloves)
unpasteurized honey 3 ⅛ cups

———

[1] Peel the garlic cloves.

[2] Place them in the glass jar and cover with honey. Leave about 2 inches
of headspace at the top of the jar to keep it from overflowing. Seal the jar
and place on a plate, as it may overflow in the first few days.

[3] For the first week, shake the closed jar every day to mix the honey with
the liquid released by the garlic. Every 2 days, release the gas that forms
in the jar by slightly opening the lid and immediately closing it.

[4] Rest 2 weeks longer. The honey will take on a more liquidy texture, like
a syrup. The garlic cloves may darken; this is normal. Once opened, store
in the fridge.

The fermented garlic can be enjoyed as is, with cheese, or as a seasoning for
vinaigrettes and soups.

For 1 (17-ounce) hermetically sealed glass jar
Preparation 5 min Storage 1 month

Lacto-Fermented Garlic with Honey

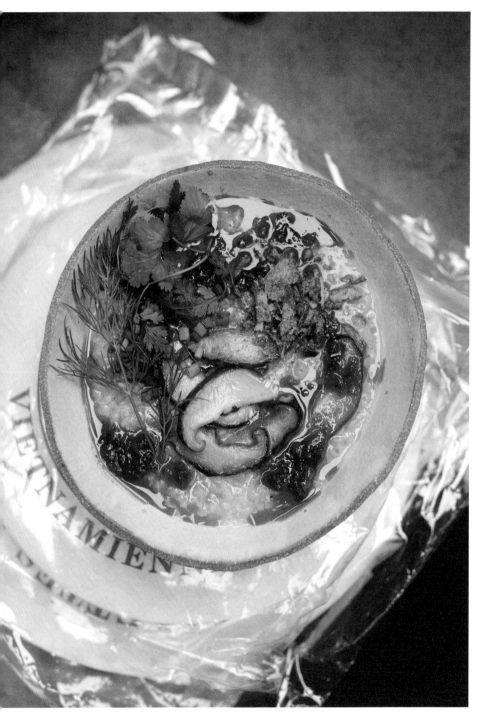

36

vegetable broth 8 ½ cups
thai rice ¾ cup + 1 tablespoon sliced shiitake mushrooms ¾ cup
iberian chorizo 3 ½ ounces
olive oil 2 tablespoons shallot 1
soy sauce 2 tablespoons
herbs (your choice) 3 ½ ounces (optional)

[1] In a large pot, combine the broth, rice, and sliced shiitake mushrooms. Cook over low heat for 1 ½ to 2 hours, or until you achieve a porridge-like consistency.

[2] Cut the chorizo into small pieces. Heat 1 tablespoon of olive oil in a pan, and cook the chorizo over low heat until its oil renders.

[3] Mince the shallot, and fry in 1 tablespoon of hot olive oil in a small pan until golden and crisp.

[4] Serve the congee in bowls. Add a drizzle of the chorizo oil and soy sauce. Garnish with herbs, if using, and fried shallot.

Serves 6 Preparation 10 min Cooking 1 hour 40 min to 2 hours 10 min

Shiitake and Chorizo Congee

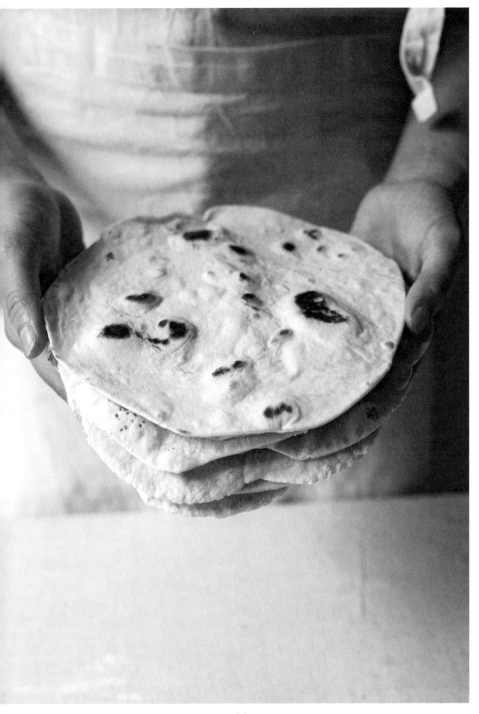

pastry flour [5 cups]
plain yogurt [½ cup]
sunflower oil [5 tablespoons] salt [1 teaspoon]
sugar [2 teaspoons] yeast [2 teaspoons]
baking powder [2 pinches]

[1] Combine the flour, yogurt, 4 tablespoons of sunflower oil, ¾ cup + 1 ½ tablespoons water, salt, sugar, yeast, and baking powder by hand, and knead for 10 minutes until you have a smooth ball of dough.

[2] Grease a bowl with the rest of the oil, place the dough ball in it, and allow to proof 1 to 2 hours.

[3] Form the dough into 10 balls about 3 ounces each, and roll them out into rounds about 1/16 inch thick.

[4] In a dry pan over high heat, cook each naan for 1 minute on each side.

For 10 naan Preparation 10 min Cooking 2 min per naan Rest 1 to 2 hours

Naan

garlic [1 clove]
yukon gold potatoes [4]
olive oil [3 tablespoons] egg [1]
naan dough rounds [2] (see recipe p. 39)
tuna [1 (5-ounce) can] black olives [6]
mayonnaise [1 heaping tablespoon]
lettuce [(your choice) 3 ½ ounces]
harissa [2 tablespoons] parsley [3 sprigs]

[1] Chop the garlic. In a mixing bowl, combine the whole, skin-on potatoes, garlic, and olive oil. Season with salt and pepper, transfer to a baking dish, and bake at 350°F for 40 minutes.

[2] In a pot of boiling water, soft-boil the egg for 6 minutes. Rinse under cold running water to stop the cooking, then peel and set aside.

[3] Roll out the naan dough to $\frac{1}{16}$ inch thick. In a dry pan over high heat, cook each naan for 1 minute on each side.

[4] Cut the roasted potatoes into pieces. Crumble the tuna and roughly chop the black olives.

[5] Spread mayonnaise over each naan. Top each naan with a soft-boiled egg half, roasted potatoes, tuna, olives, a few lettuce leaves, and a few drops of harissa. Sprinkle with chopped parsley and serve immediately.

Makes 2 naan Preparation 10 min Cooking 50 min

Egg, Tuna, Potato, and Harissa Naan

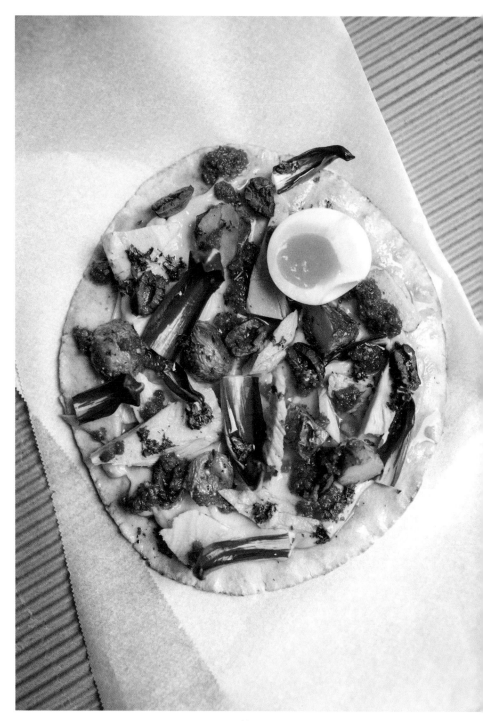

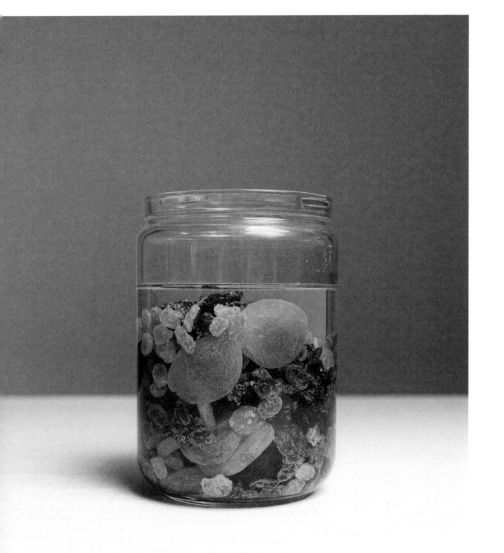

dried fruit [1¼ cups]

(figs, raisins, cranberries...)

mineral water [3 cups]

———————

[1] Place the dried fruit in the glass jar.

[2] Cover with the mineral water, then seal the jar and cover with a piece of cloth tied with a string.

[3] Place the jar in a cool, dark place. Wait 15 days before using. Once opened, store the jar at room temperature, away from light.

This fruit vinegar can be used in a vinaigrette or marinade, and it can also be enjoyed as part of a cleanse. Consume 1 tablespoon before and after meals for a month, to help lower blood sugar.

For 1 (33-ounce) hermetically sealed glass jar

Preparation 10 min Rest 15 days Keeps 1 year

Dried Fruit Vinegar

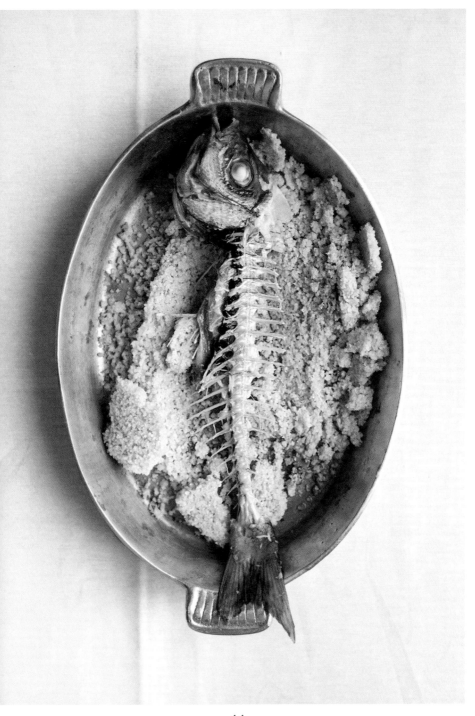

whole cleaned, unscaled sea bream [1]
fennel seeds 2 tablespoons
crushed black pepper 1 teaspoon
coarse sea salt 2 ¼ pounds
egg whites [2]

[1] Pat the sea bream dry with paper towels. Season with fennel seeds and pepper.

[2] Preheat the oven to 400°F.

[3] In a mixing bowl, combine the salt and the egg whites. Place a layer of this mixture in a baking dish, then place the sea bream on top. Cover with another layer of the salt mixture, and pack down well so that the fish is completely sealed in by salt on all sides.

[4] Bake 10 minutes.

[5] Turn off the oven, leaving the oven door closed. Allow the fish to rest in the cooling oven for 10 minutes more.

[6] Break the salt crust and serve.

Serves 2 Preparation 20 min Cooking 10 min Rest 10 min

Sea Bream in a Salt Crust

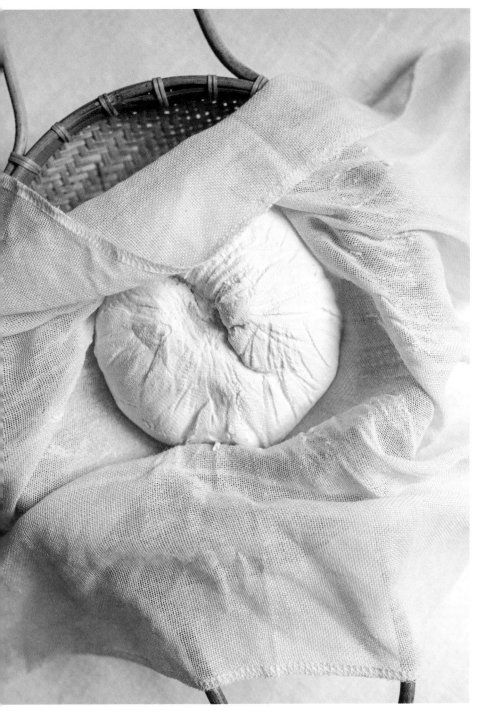

whole milk ^{6 ⅓ cups}

lemon ^{juice of 1 (or 3 tablespoons of white wine vinegar)}

salt ^{1 teaspoon}

[1] In a large, heavy-bottomed pot, bring the milk to a near boil (around 195°F), stirring it regularly. As soon as bubbles appear, add the lemon juice or vinegar, and stir to combine. Remove from the heat and set aside at room temperature for 30 minutes.

[2] Remove the curds and transfer them to a cheesecloth. Drain for 20 to 45 minutes, depending on your desired texture. The longer you drain the cheese, the firmer the texture of the cheese will be.

[3] Remove the cheese from the cheesecloth. Season with salt and chill at least 1 hour before serving.

This fresh cheese can be enjoyed as is, but it can also be molded and tossed in aromatics. In this case, it should be enjoyed after chilling several days.

Makes 17 ounces of cheese

Preparation 10 min Cooking 10 min Rest 1 hour 50 min to 2 hours 15 min

Homemade Fresh Cheese

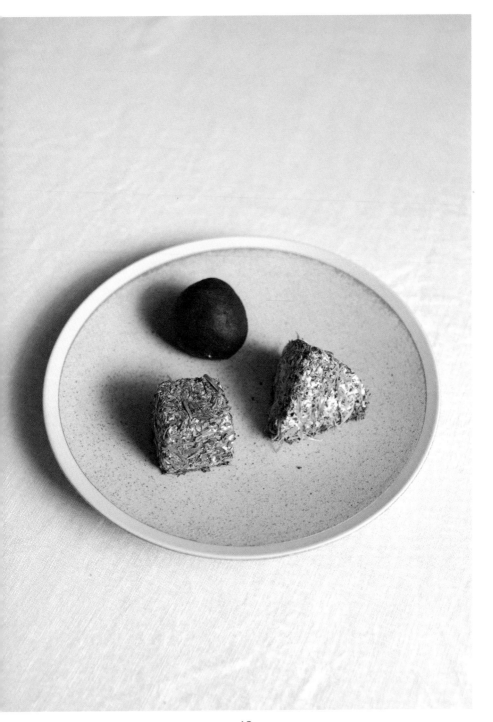

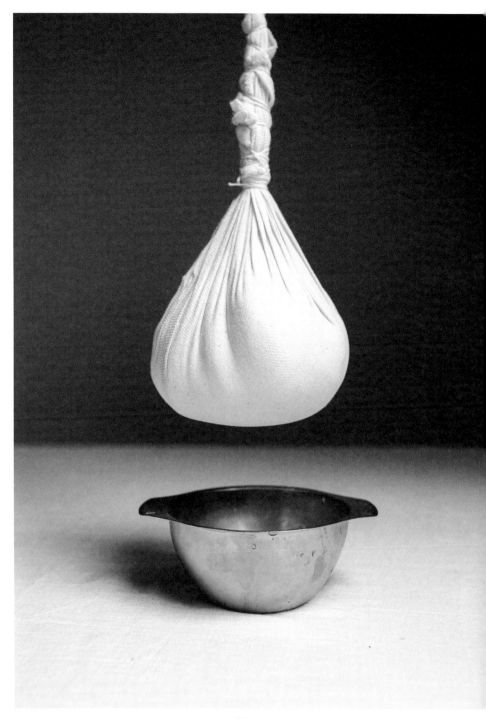

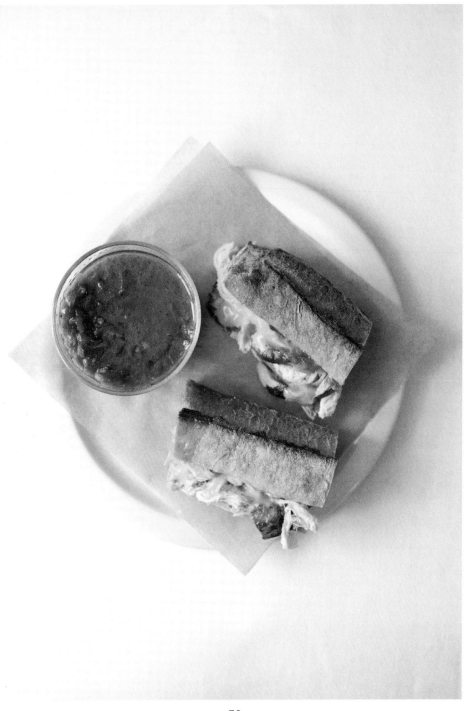

Chicken jus

sunflower oil [1 tablespoon]

picked over roast chicken carcass [1] onion [1] garlic [1 clove]

thyme [1 sprig] bay [1 leaf] white wine [⅔ cup]

chicken broth [¾ cup + 1 tablespoon]

Mayonnaise

garlic [1 clove] mustard [1 tablespoon]

egg yolk [1] sunflower oil [¾ cup + 1 ½ tablespoons]

baguette [1] leftover chicken [2 ¼ cups]

Make the chicken jus

[1] In a saucepan, heat the oil. Chop the onion, chicken carcass, garlic, and thyme leaves separately. Sauté the onion and caramelize 2 minutes. Add the chicken carcass, garlic, thyme, and bay leaf. Mix well.

[2] Deglaze with the wine over high heat. Reduce almost completely over medium heat. Add the broth, continue reducing until you have a thick jus.

Make the mayonnaise

[3] Chop the garlic. Emulsify the egg yolk with the mustard and the oil in a bowl. Add the garlic and stir to incorporate.

[4] Halve the baguette and split each half lengthwise. Spread mayonnaise on each piece. Add the roast chicken pieces to the bottom halves of the baguette, then top with the top halves. Serve with the chicken jus on the side for dipping.

Serves 2 Preparation 10 min Cooking 10 min

Leftover Roast Chicken Sandwich

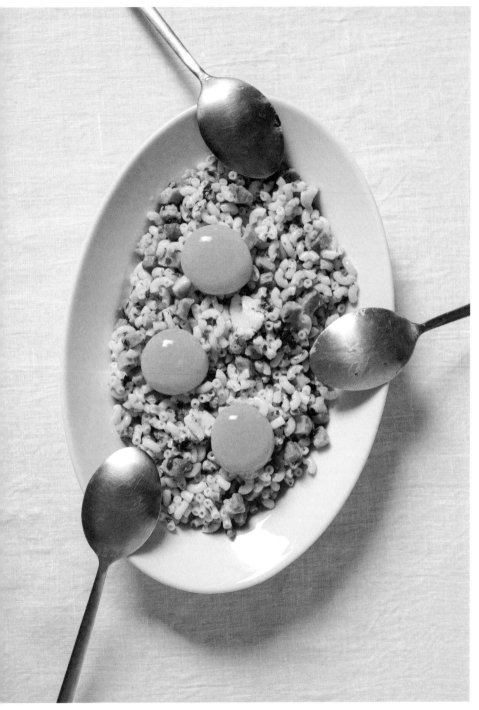

pancetta ^{7 ounces}

coquillettes ^{3 cups (or elbow macaroni)}

white wine ^{3 tablespoons + 1 teaspoon} olive oil ^{1 drizzle}

vegetable broth ^{¾ cup + 1 ½ tablespoons}

seaweed butter ^{3 ½ ounces (about 7 tablespoons) (see recipe p. 23)}

ground black pepper ^{1 teaspoon}

egg yolks ³

──────────

[1] Dice the pancetta. In a pan, sauté the pancetta in a bit of olive oil. Cook for 2 minutes, stirring all the while.

[2] Add the pasta and cook over medium heat for 2 minutes. Deglaze with white wine, and reduce. Add the broth, and cook, stirring all the while, for 8 minutes.

[3] When the pasta is cooked, add the seaweed butter (see recipe p. 23) and the black pepper. At the last minute, add the raw egg yolks, and serve.

Serves 3 Preparation 5 min Cooking 12 min

Coquillettes with Seaweed Butter and Pancetta

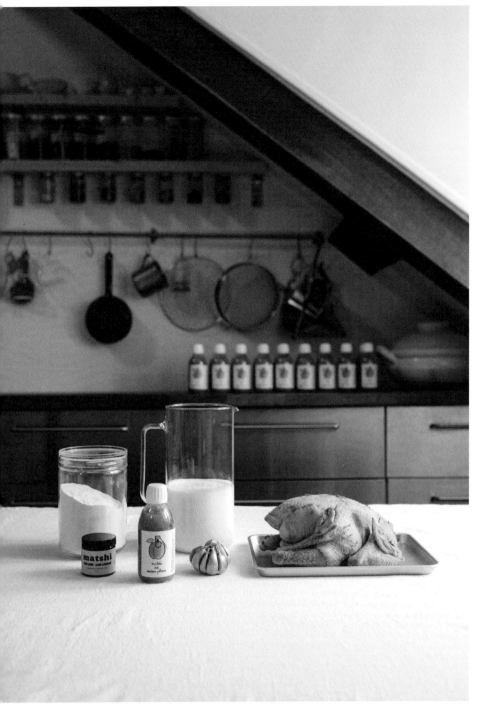

garlic ³ cloves whole chicken ¹

buttermilk ⁴ ¼ cups

flour ⁴ cups chile powder ¹ tablespoon

frying oil ³ to 4 cups

mild chile sauce (to taste)

———

[1] Crush the garlic cloves.

[2] Cut the chicken into pieces and place in a mixing bowl. Add the buttermilk and crushed garlic, and mix well. Cover and marinate 24 hours in the fridge.

[3] In a large mixing bowl, combine the flour with the chile powder. Toss the chicken pieces in the mixture, then set on a rack.

[4] In a pot, heat the oil to 320ºF, and fry the chicken pieces for 15 minutes. Drain and fry a second time at 375ºF for 1 or 2 minutes. Drain.

[5] Toss the chicken in the mild chile sauce and serve.

Serves 4 Marinade 24 hours Preparation 30 min Cooking 17 min

Buttermilk Fried Chicken

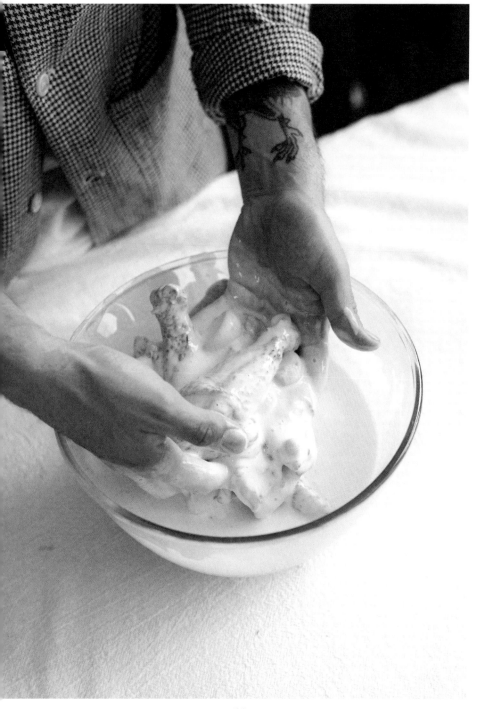

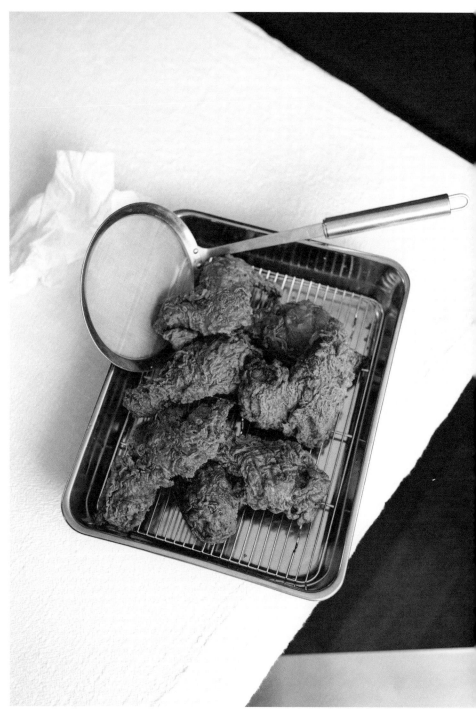

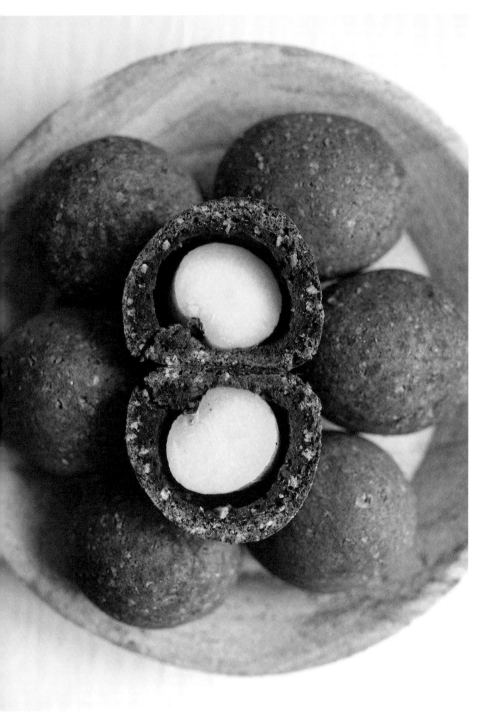

flour ^{1 ½ cups + 1 ½ tablespoons}
coarse sea salt ^{⅔ cup}
egg whites ²
ground coffee ^{6 tablespoons}
medium potatoes ⁸

[1] Mix and then knead together the flour, salt, egg whites, and coffee until the dough is smooth and slightly crumbly, like a shortbread dough.

[2] Wash and dry the potatoes well.

[3] Cover each potato with a thick layer of the dough. Roll the potatoes so that the dough layer is smooth and even, taking care to ensure it covers each potato completely.

[4] Bake at 340°F for 35 minutes.

[5] Just before serving, cut the potatoes in half and enjoy without eating the crust.

Serves 4 Preparation 10 min Cooking 35 min

Potatoes in
a Salt and Coffee Crust

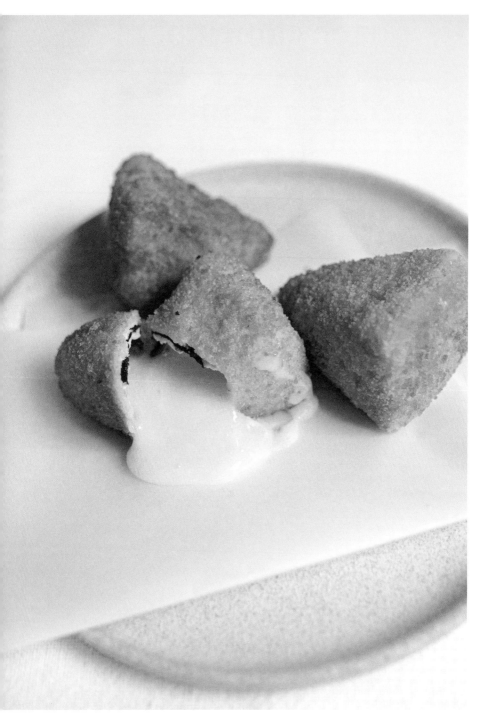

ripe camembert [1 wheel]
nori [1 sheet] flour [1 tablespoon]
egg [1] breadcrumbs [4 tablespoons]
frying oil [1 ¼ cups]

———

[1] Cut the Camembert into 8 equal wedges, and wrap each one in a nori sheet. Toss them lightly in flour.
[2] Beat the egg in a shallow bowl. Add the breadcrumbs to another. Dip the Camembert pieces first in the egg, then in the breadcrumbs.
[3] Heat the oil in a frying pan. Fry the Camembert pieces 3 to 4 minutes in the hot oil, turning to brown on all sides. Enjoy hot.

Serves 2 Preparation 5 min Cooking 4 min

Fried Camembert with Nori

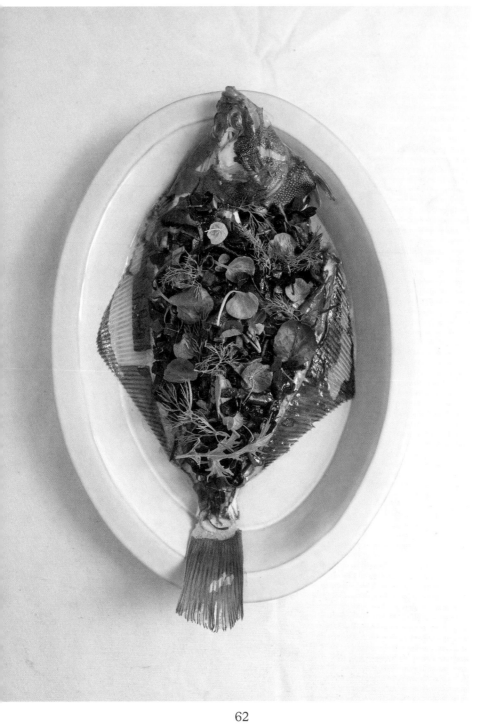

flat fish [1] (plaice, lemon sole, sole...)

olive oil [2] tablespoons

dried seaweed [2] ounces (wakame, sea lettuce, dulse)

watercress [1] (7-ounce) bunch

garlic [2] cloves butter [7] tablespoons

dill [2] sprigs citrus zest (your choice) 1

[1] Clean the fish and place in a baking dish. Season with salt, pepper, and oil.

[2] In a mixing bowl, cover the seaweed with cold water, and soak for 10 minutes to rehydrate. Drain.

[3] Wash the watercress and remove the stems. Chop the garlic.

[4] In a small pan, heat the butter over low heat until foamy. Add the garlic and sauté. As soon as the butter stops foaming and takes on a golden color, remove from the heat. Add the seaweed and watercress and toss well to coat.

[5] Bake the fish for 15 minutes at 350ºF.

[6] Once the fish is cooked, remove the top layer of skin and drizzle with the seaweed and watercress butter. Garnish with fresh watercress, dill, and citrus zest, and serve immediately.

Serves 2 Preparation 25 min Cooking 20 min

Fish with Seaweed and Browned Butter

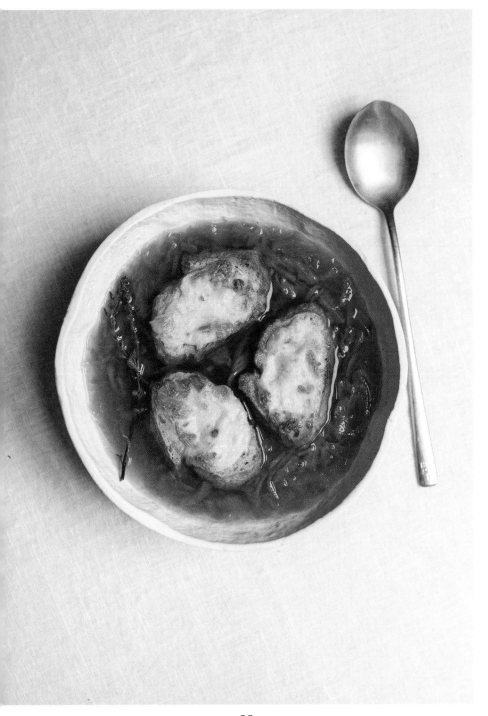

yellow onions [4] sugar [2 ½ teaspoons]
chicken broth [4 ¼ cups]
nuoc mam [1 tablespoon]
white pepper [1 teaspoon]
grated emmental cheese [3 ½ ounces (heaping ¾ cup)]
crème fraîche [2 tablespoons]
baguette [12 slices] thyme [4 sprigs]

[1] Thinly slice the onions.

[2] In a pot, dissolve the sugar in 1 tablespoon cold water over low heat. As soon as it begins to foam, add the onions. Stir to combine, and cook over low heat for 4 minutes.

[3] Add the chicken broth, the nuoc mam, and the white pepper. Continue cooking over low heat for 30 minutes, until the liquid cooks down.

[4] In a bowl, combine the grated emmental cheese with the crème fraîche. Spread the mixture over the bread slices.

[5] Place the bread slices on a baking sheet, and bake at 350°F for 5 minutes.

[6] Serve the soup in bowls topped with the cheesy bread slices and the thyme.

Serves 4 Preparation 10 min Cooking 40 min

Caramelized Onion Soup

active dry yeast [1 teaspoon]
milk [1 ¼ cups] eggs [2]
buckwheat flour [¾ cup + 1 tablespoon]
wheat flour [6 ½ tablespoons]
sunflower oil [1 drizzle]

[1] Dissolve the yeast in a bit of warm milk, and rest at room temperature for 15 minutes.

[2] Separate the egg yolks from the whites. Set the whites aside.

[3] In a bowl, combine the yolks with the flours and a bit of salt. Slowly add the milk (including the milk with the yeast in it) into the dough. Mix until a smooth dough forms. Set aside to rest at room temperature for 1 hour, until it doubles in size.

[4] Beat the egg whites to stiff peaks, and fold into the dough with a rubber spatula.

[5] Heat a bit of oil in a nonstick pan. Add a tablespoon of dough, spread out lightly, and cook over low heat for 4 to 5 minutes on one side. Flip and cook 2 to 3 minutes on the other side. Continue until you have used all of the dough.

Enjoy the blini with taramasalata, salmon roe, or use as a sandwich base.

Serves 6 (makes 30 small blini)
Preparation 15 min Cooking 6 to 8 min per blini Rest 1 hour 15 min

Buckwheat Blini

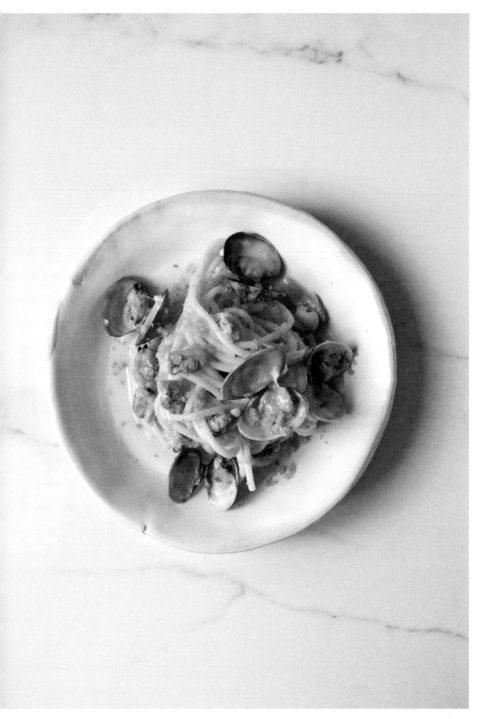

small dried chile [1] garlic [1 clove]
parsley [1 tablespoon] olive oil [2 tablespoons]
clams [1 pound 12 ounces] sake [⅔ cup]
spaghetti [7 ounces]
grated bottarga [2 tablespoons]

[1] Crumble the chile, and chop the garlic and the parsley separately.
[2] In a pan, heat the olive oil. Add the chile and garlic, heat over medium without browning.
[3] Add the clams and the sake, then cover and cook until the clams open. Remove the clams with a slotted spoon and set aside at room temperature, reserving the rendered juices in the pan. Discard any clams that don't open.
[4] Bring a large pot of water to a boil. Cook the spaghetti until just before al dente, then drain, reserving 1 ladleful of cooking water.
[5] Add the pasta to the cooking juices from the clams, and add the ladleful of cooking water. Cook for 2 to 3 minutes over low heat, stirring to emulsify the sauce. Add the clams and parsley at the last minute. Sprinkle with grated bottarga, and serve immediately.

Serves 2 Preparation 10 min Cooking 20 min

Spaghetti alle Vongole with Sake

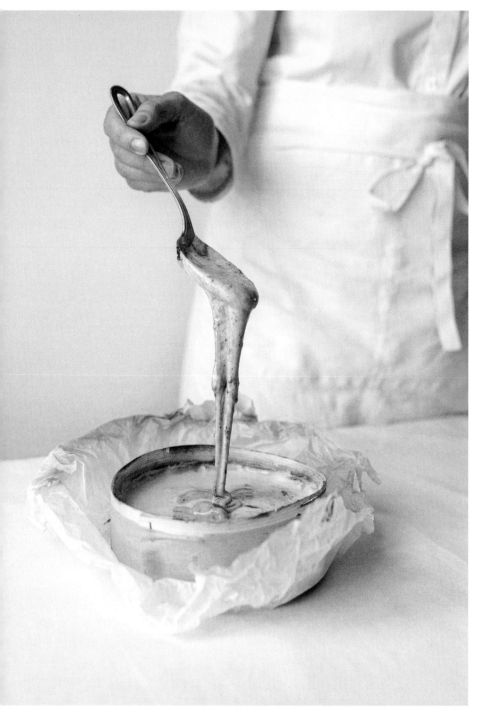

black garlic ^{5 cloves}
mont d'or cheese ¹
whisky ^{1 tablespoon}

[1] Preheat the oven to 400ºF.
[2] In a mortar, crush the black garlic into a paste.
[3] Place the Mont d'Or on a baking sheet lined with parchment paper.
 Cut an x into the crust of the cheese, and push the black garlic paste inside.
[4] Drizzle with the whisky and bake 20 minutes. Serve hot with bread.

Serves 2 Preparation 10 min Cooking 20 min
Mont d'Or with Black Garlic and Whisky

masa harina ^{3 ½ cups}
salt ^{1 pinch}

———

[1] In a mixing bowl, combine the masa harina, salt, and ¾ cup water.
Knead until the dough is firm but crumbly, adding more water as needed.
Form the dough into a smooth ball, cover with a dish towel, and leave
to rest at room temperature for 30 minutes.

[2] Divide the dough into 20 equal pieces (about 1 ounce each), and flatten
using a tortilla press or a rolling pin.

[3] Cook each tortilla in a dry pan over medium heat for 1 minute per side.
Set aside in a dish towel and keep warm.

To make tostadas, fry the tortillas in 350ºF oil for 2 minutes until golden
brown and crisp.

Makes 20 small tortillas
Preparation 10 min Cooking 2 min per tortilla Rest 30 min

Corn Tortillas

red onion [1] garlic [1 clove]

guajillo chiles [3] árbol chile [1]

peeled tomatoes [1 (14 ½-ounce) can]

oregano [1 tablespoon] bay [1 leaf]

olive oil [1 tablespoon]

———

corn tortillas [10] (see recipe p. 77)

sunflower oil [7 tablespoons] eggs [2]

feta [3 ½ ounces] red onion [¼]

cilantro [4 sprigs]

———

[1] Quarter the red onion, and sauté over low heat in a dry pan. Chop the garlic and add it with the chiles to the pan. Sauté 2 minutes.

[2] Transfer the mixture to a blender. Add the tomatoes and blend lightly, taking care to keep the paste a bit chunky.

[3] Put the mixture into a saucepan. Add the oregano, bay leaf, and olive oil, and cook over medium heat for 20 minutes.

[4] Quarter the tortillas. In a pot, heat the sunflower oil to 350ºF, and fry the tortillas for 3 minutes. Drain on paper towels.

[5] Fry the eggs sunny-side up.

[6] Crumble the feta with your fingertips, and mince the onion. Finely chop the cilantro.

[7] Add the tortilla chips to the sauce, and toss well to coat.

[8] Serve some chips on each plate, and add an egg per person. Sprinkle with feta, red onion, and cilantro. Serve hot.

Serves 2 Preparation 10 min Cooking 30 min

Chilaquiles Rojos

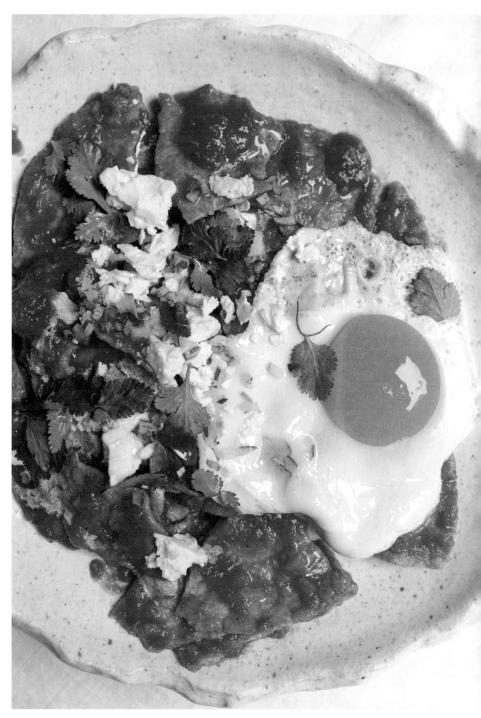

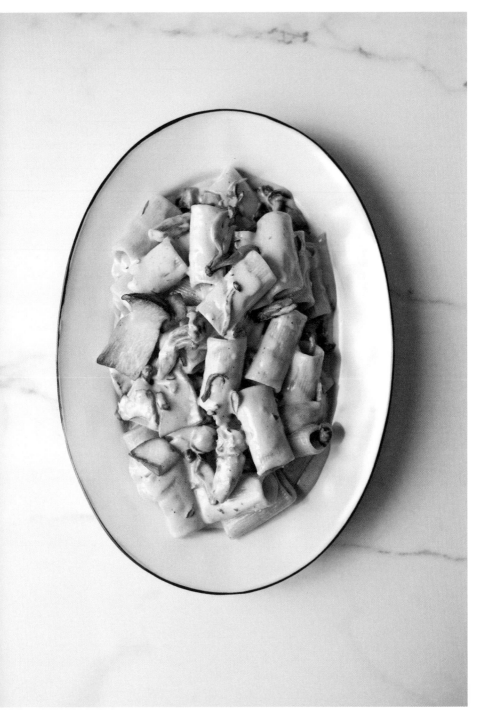

olive oil ^{3 tablespoons} garlic ^{1 clove}
mushrooms ^{1 pound 1 ounce (your choice)}
heavy cream ^{⅓ cup + 1 ½ tablespoons}
sake kasu ^{2 tablespoons}
soy sauce ^{1 tablespoon}
grated parmesan ^{¾ cup}
rigatoni ^{1 ½ pounds} butter ^{3 ½ tablespoons}

[1] In a pan, heat the olive oil. Crush the garlic and add it with the roughly
 sliced mushrooms, and sauté 5 minutes.

[2] In a small bowl, mix the heavy cream with the sake kasu, soy sauce,
 and Parmesan.

[3] Bring a large pot of water to a boil. Cook the rigatoni for 8 to 9 minutes
 (until just before al dente), then drain, reserving 1 ladleful of
 cooking water.

[4] Over low heat, add the rigatoni to the mushrooms, along with the
 ladleful of cooking water. Toss and add the cream mixture to the pan.
 Stir continuously until the sauce thickens. Serve immediately.

Serves 6 Preparation 10 min Cooking 18 min

Rigatoni with Mushrooms and Sake Kasu

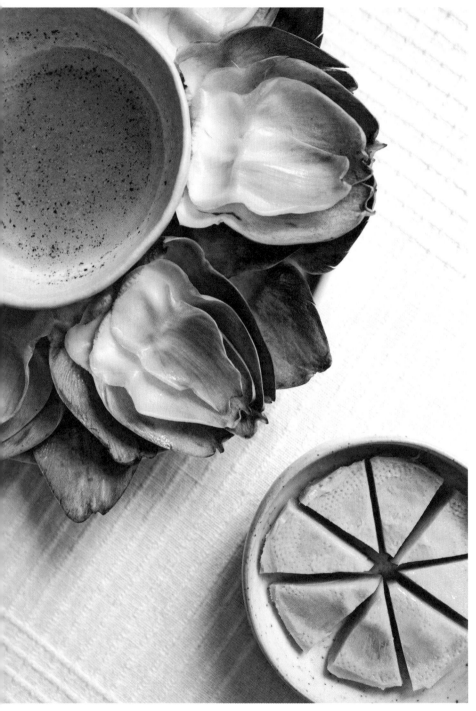

artichokes 2

mirin 3 tablespoons soy sauce 2 tablespoons

rice vinegar 1 tablespoon

Honey Vinaigrette

garlic ½ clove honey 2 tablespoons

lemon juice 1 tablespoon

soy sauce 1 teaspoon olive oil 5 tablespoons

salt 2 pinches black pepper 1 pinch

[1] Break the stem end off of the artichokes. Place the artichokes in a large pot, and cover with about 12 cups water, the mirin, soy sauce, and rice vinegar. Cook over medium heat for 45 minutes, then remove from the heat and allow the artichokes to cool in the broth.

Make the honey vinaigrette

[2] Grate the garlic finely and place in a bowl. Add the honey, olive oil, lemon juice, soy sauce, salt, and pepper. Whisk with a fork to combine.

[3] Drain the artichokes. Remove all of the leaves, and use a knife to remove the prickly choke. Cut the heart into six or eight pieces, depending on its size. Serve the warm artichokes with the vinaigrette.

Serves 2 Preparation 15 min Cooking 45 min

Artichokes
with Honey Vinaigrette

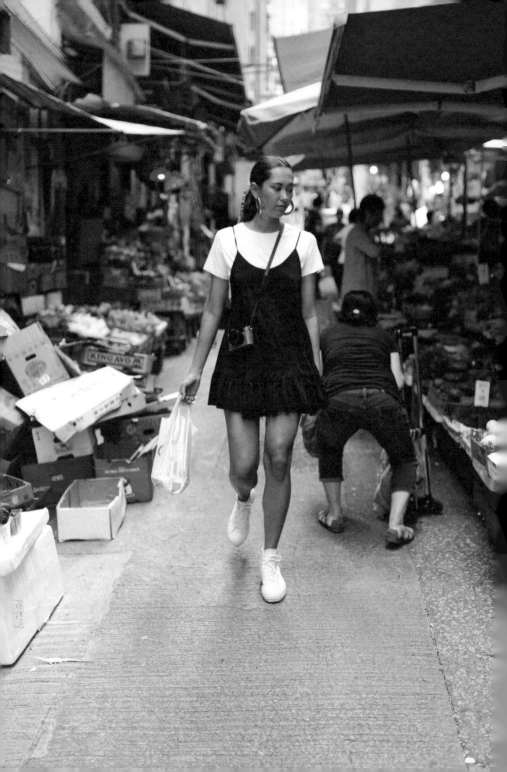

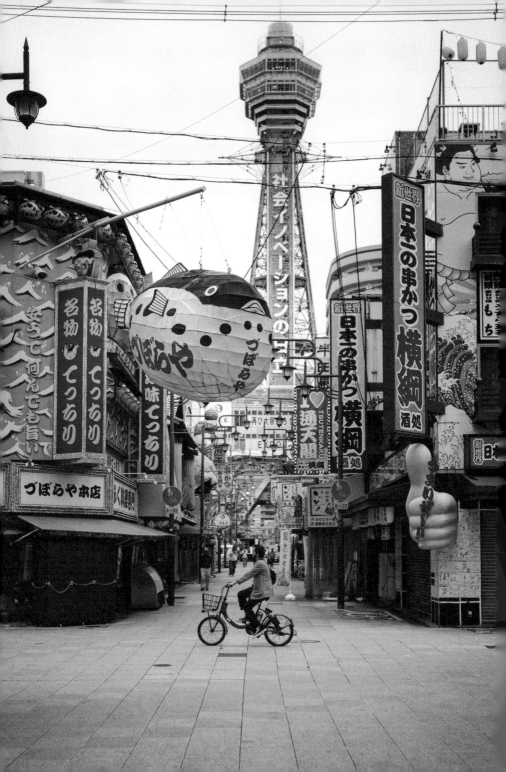

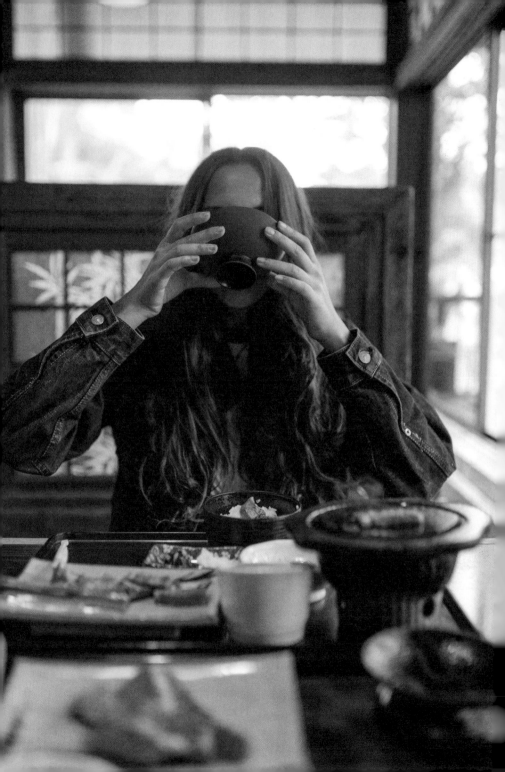

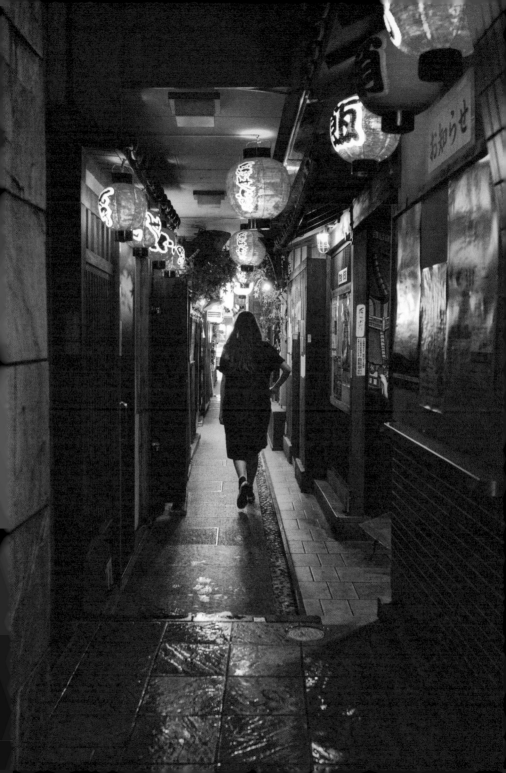

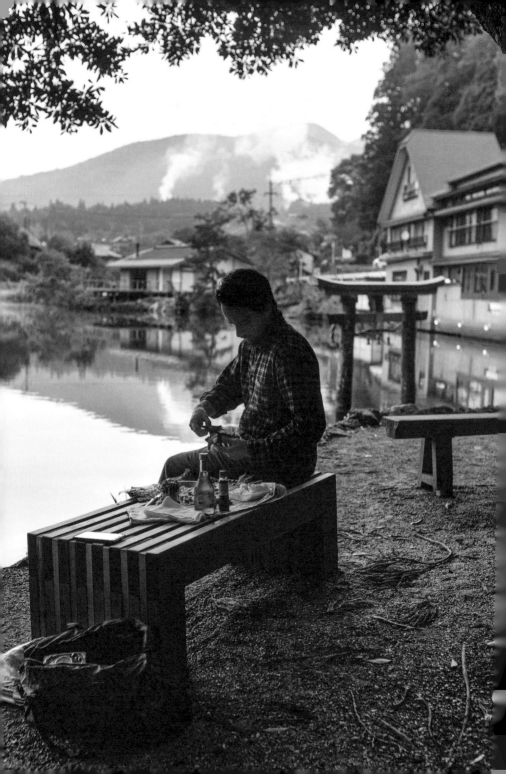

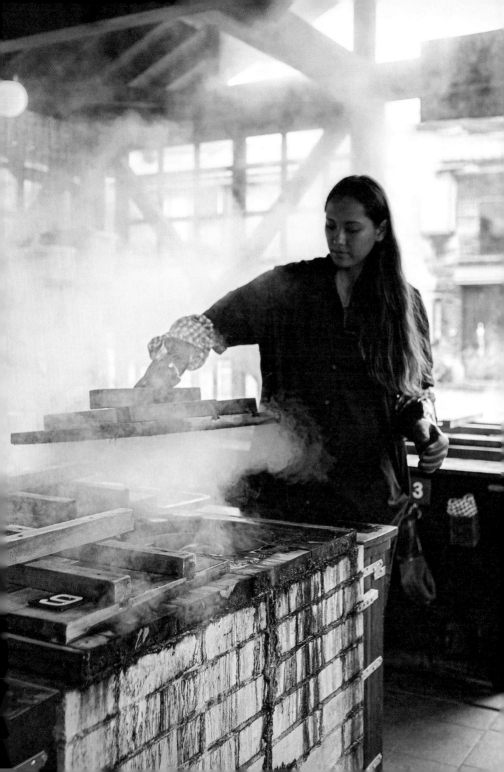

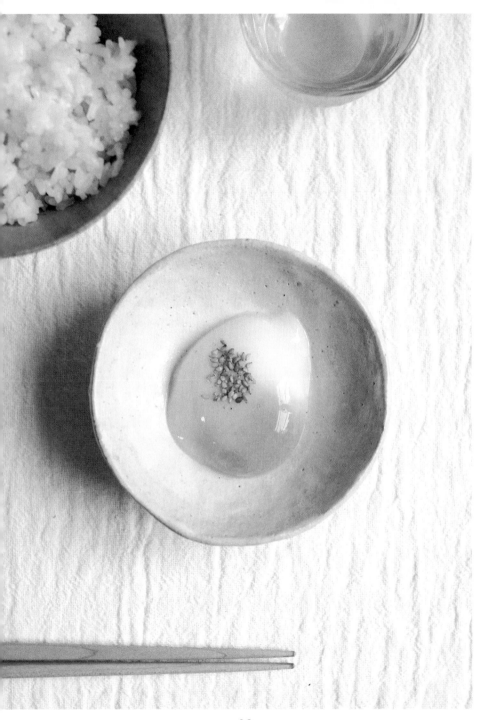

eggs [2]
sesame seeds [1 teaspoon]
soy sauce [2 tablespoons]

[1] Take the eggs out of the fridge and let them come to room temperature.
[2] Bring 4 ¼ cups water to a boil in a saucepan. When the water comes to a boil, add 1 cup cold tap water and remove from the heat.
[3] Add the whole eggs in their shells and cover. Let sit 25 to 30 minutes.
[4] Break each egg into a small ramekin and sprinkle with the sesame seeds. Serve with the soy sauce.

This dish is ideal with white rice or miso soup.

Serves 2 Cooking 25 to 30 min
Onsen Tamago

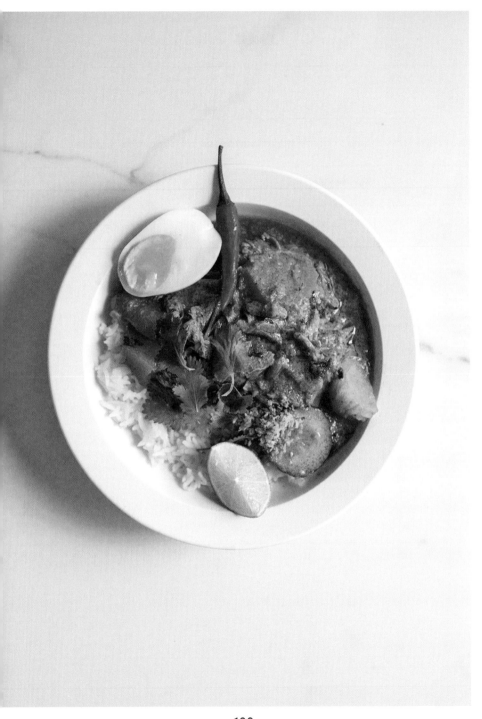

coconut milk 2 ⅛ cups
massaman curry paste 2 tablespoons + 2 ¼ teaspoons
chicken thighs 4
nuoc mam 1 tablespoon
brown sugar 2 tablespoons
small potatoes 2 onion 1
zucchini 1
roasted peanuts 1 tablespoon
cilantro 3 sprigs
tamarin juice 2 tablespoons (optional)

[1] Pour half of the coconut milk into a pot, and reduce over high heat
 until you have a nice coconut cream.
[2] Incorporate the curry paste, and cook over low heat for a few minutes.
 Add the chicken pieces, and toss them well to coat in the curry paste.
[3] Add the remaining coconut milk, the nuoc mam, brown sugar, and
 tamarind juice, if using. Cook over low heat for 20 minutes.
[4] Peel the potatoes and chop the onion. Add the potatoes and onion to the
 pan, and continue cooking over low heat for 20 minutes.
[5] Slice the zucchini into rounds. Add to the pot and cook for 10 minutes.
[6] Grind the roasted peanuts into a powder.
[7] Serve the massaman curry with a few sprigs of cilantro, sprinkled with
 the peanut powder, and with white rice and ½ a soft-boiled egg per
 person, if desired.

Serves 4 Preparation 10 min Cooking 50 min

Massaman Chicken Curry

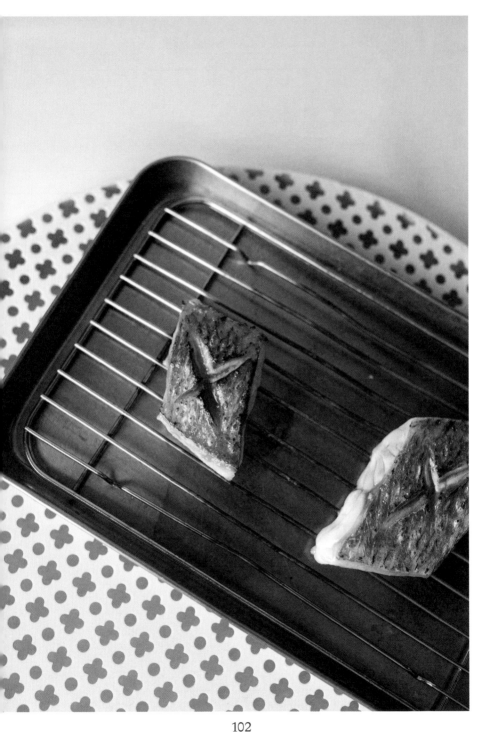

sencha green tea ^{2 teaspoons}

sencha green tea 2 teaspoons
mineral water 1 ½ cups
red mullet 1 fillet dill 2 sprigs
olive oil 2 tablespoons + 2 teaspoons
cooked japanese rice 1 cup
soy sauce 1 teaspoon (optional)
wasabi (optional)

[1] Place the tea in a teapot, and pour hot mineral water (preferably at 158ºF) over the top. Infuse 1 minute.

[2] Cut the red mullet in half, and score a cross on the skin side of each piece. Season with salt and 2 teaspoons olive oil on both sides, and cook the skin side for 1 minute with a kitchen blowtorch.

[3] Mince the dill. Mix with 2 tablespoons of olive oil, rice, and a good pinch of salt. Form 2 small balls of rice by hand.

[4] Place the rice balls in the serving bowls. Place the red mullet on the rice, and pour the hot tea over the top. Serve immediately with a bit of soy sauce or wasabi, if desired.

Serves 2 Preparation 10 min Cooking 2 min

Red Mullet Ochazuke

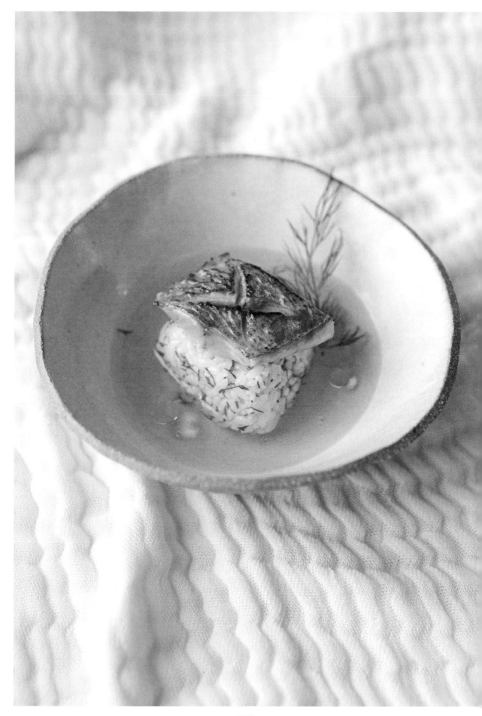

rice koji 7 ounces
sea salt 2 tablespoons + ¾ teaspoon

[1] Place the rice koji, salt, and 1 cup water in a jar, and mix well to combine.
[2] Leave 20 days in a dark place at around 68°F, opening once a day and
stirring with a spoon.
[3] After 20 days, store in the fridge.

Shio koji can be used to flavor marinades, sauces, and salad dressings.

For 1 (17-ounce) hermetically sealed glass jar
Preparation 10 min Rest 20 days Keeps 1 year

Shio Koji

japanese white rice ^{1 ½ cups}
mineral water ^{1 ⅔ cups}

Vinegar-
seasoned rice

salt ^{2 pinches} sugar ^{2 tablespoons + 1 teaspoon}
rice vinegar ^{4 tablespoons + 2 ¼ teaspoons}
cooked rice ^{1 ⅔ cups}

[1] Wash the rice in cold tap water, mixing it with your hand.
 When the water becomes cloudy, change it. Repeat about 5 times,
 or until the water is clear.
[2] Once you have washed the rice, soak it for at least 30 minutes in tap
 water, then drain.
[3] Place the rice in a saucepan and add the mineral water. Cook, covered,
 over high heat until the water comes to a boil. When it reaches a boil,
 reduce the heat and simmer, covered, for 15 to 20 minutes.
[4] Remove the saucepan from the heat and allow the rice to rest, covered,
 for 10 to 15 minutes. Fluff the rice with a spoon, then cover once more.

For a vinegar-seasoned rice
[1] Completely dissolve the sugar and salt in the vinegar.
[2] Transfer 1 ⅔ cups of the cooked rice to a wooden mixing bowl,
 and add the vinegar mixture. Delicately mix to combine, aerating
 with a handheld fan all the while.

Serves 6 Preparation 10 min Cooking 20 to 25 min Rest 40 to 45 min
Japanese-Style Rice
and Vinegar-Seasoned Rice

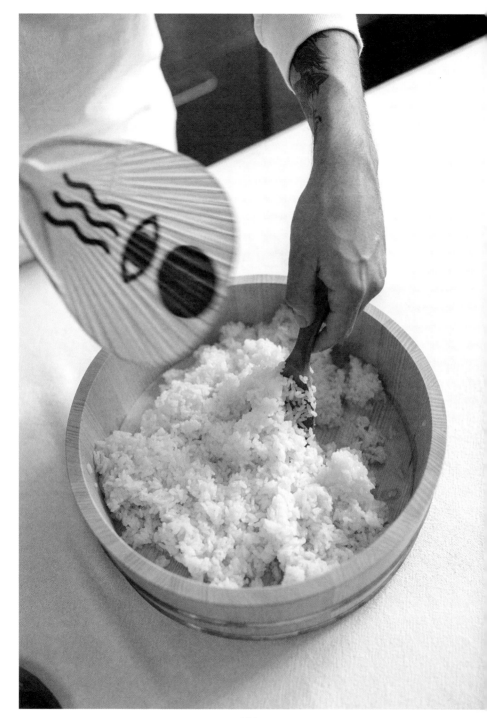

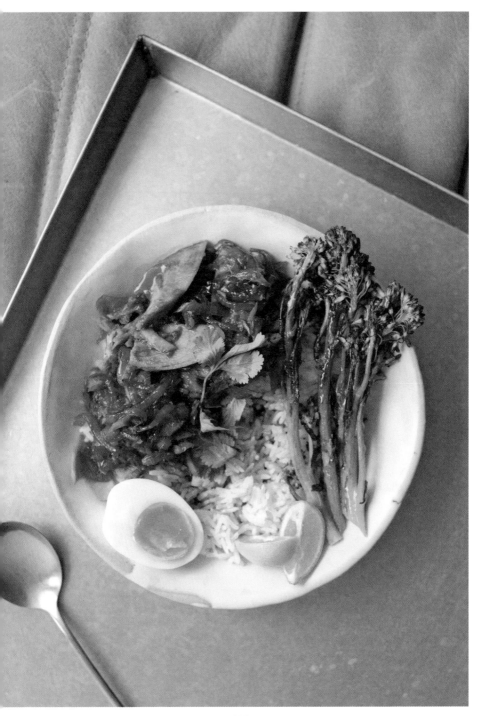

garlic 1 clove ginger 1 (4-inch) piece
tuna 1 (12-ounce) can nuoc mam 3 tablespoons
onion 1 vegetable oil 1 tablespoon
sugar ¾ cup + 1 tablespoon
white pepper 1 pinch
bird's-eye chile 1

———

[1] Chop the garlic. Peel and grate the ginger.

[2] In a bowl, combine the drained and roughly crumbled tuna, the nuoc mam, the garlic, and the ginger. Rest for 30 minutes.

[3] Dice the onion. In a large pot, heat the vegetable oil and the sugar over high heat until a light caramel forms. Add the onion and cook over high heat for 5 minutes more.

[4] Add the contents of the bowl with tuna and continue cooking over low heat for 2 minutes.

[5] Add water to cover. Bring to a boil, then cook, covered, over medium heat for 5 minutes. Season with white pepper and add the bird's-eye chile.

[6] Serve immediately, with white rice, a ½ a soft-boiled egg per person, and vegetables, if desired.

Serves 2 Preparation 10 min Cooking 26 min Rest 30 min

Canned Tuna with Caramelized Sauce

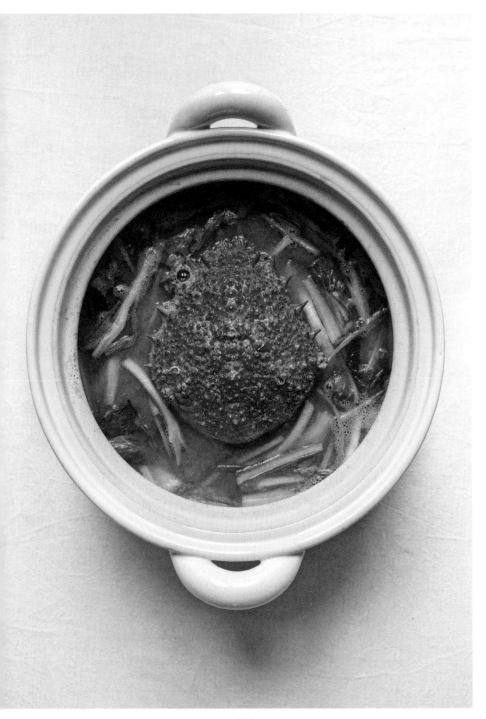

filtered water [8 ½ cups]
spider crab [1]
bonito flakes [1 handful]
soy sauce [3 tablespoons]
white miso [4 tablespoons]
spinach [2 ounces] scallions [3]
dried wakame [½ ounce]

[1] In a large pot, bring the filtered water to a boil. Add the whole live spider crab. Cook 20 minutes, reserve the cooking liquid in the pot. Remove the legs and crack them with a rolling pin or hammer. Reserve them with the meat for the broth. Cut and open the body, pick the meat out and, set aside with the shell.

[2] Add the bonito flakes and soy sauce to the cooking liquid. Cook for 10 minutes over very low heat. Strain the resulting broth into a saucepan and add the miso.

[3] Roughly chop the spinach and cut the scallions into 1 ½-inch lengths. Add to the broth along with the crab meat and the wakame. Cook 2 minutes over low heat.

[4] Serve in a large soup tureen or a donabe. Garnish with the reserved crab shell.

Serves 6 Preparation 40 min Cooking 32 min

Miso Soup
with Spider Crab

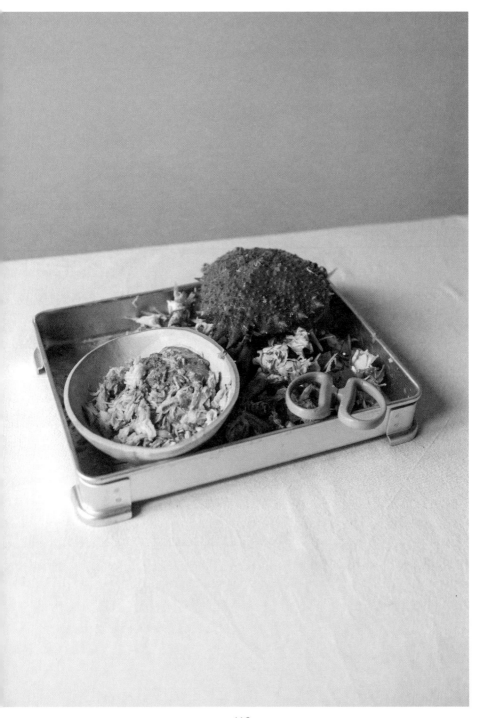

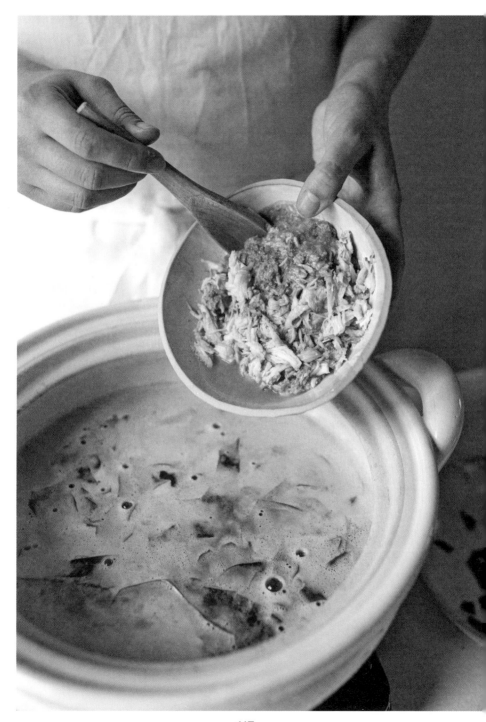

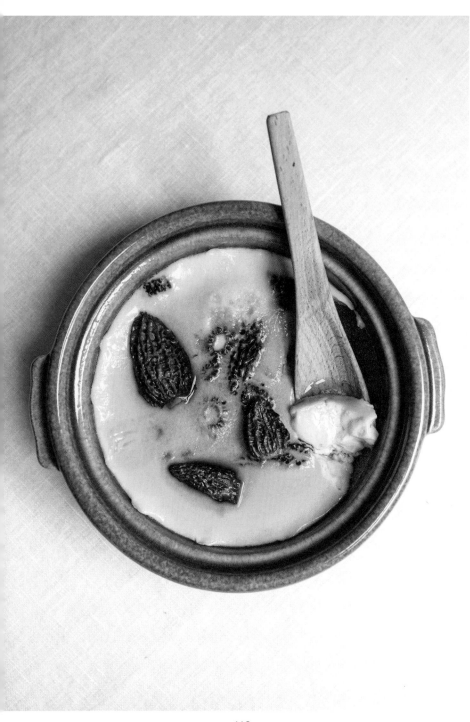

eggs [3]
vegetarian dashi 1 cup (see recipe p. 161)
soy sauce 1 teaspoon
sake 1 teaspoon salt 1 pinch sugar 1 teaspoon
dried morel mushrooms 4 pieces

[1] Prepare the vegetarian dashi (see recipe p. 161).
[2] In a bowl, combine the dashi with the soy sauce, sake, salt, and sugar. Add the morels to rehydrate them; remove after 1 hour.
[3] In another bowl, lightly beat the eggs, taking care not to let them become foamy.
[4] Add the dashi mixture to the beaten eggs, and mix well. Strain through a chinois into a bowl to ensure that the cream is totally smooth.
[5] Distribute two whole or halved morels into each of two ramekins, then fill with the egg mixture.
[6] Preheat a steam cooker, and place the ramekins in it. Cook on low for 15 minutes. Check the doneness of the chawanmushi by piercing it with a toothpick; if egg clings to it, cook several minutes more until set.

Serves 2 Preparation 10 min Cooking 15 min Rest 1 hour

Morel Mushroom Chawanmushi

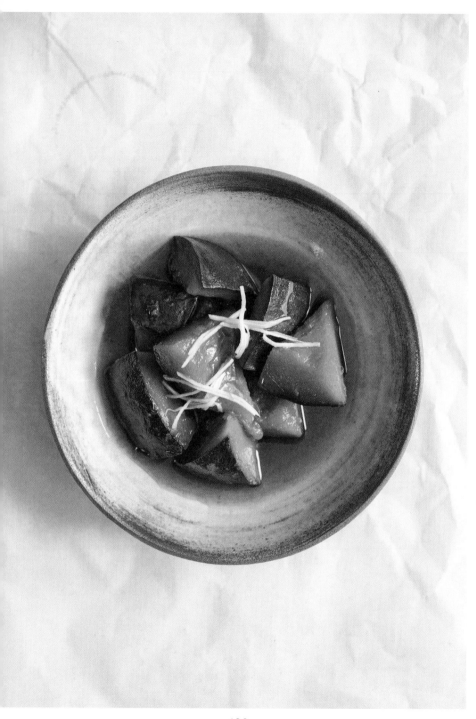

small kabocha squash [1]
vegetarian dashi 2 ¼ cups (see recipe p. 161)
ginger 1 (2-inch) piece
sugar 3 tablespoons soy sauce 3 tablespoons
sake 2 tablespoons mirin 1 tablespoon
bonito flakes 1 tablespoon

[1] Prepare the vegetarian dashi (see recipe p. 161).
[2] Halve the kabocha squash. Remove the seeds and membranes with a spoon. Rinse the outside of the squash to clean.
[3] Cut the squash into about 1-inch cubes. Place them, skin-side down, in a medium pot in one layer. Take care not to overcrowd the pan.
[4] Peel and julienne the ginger. Add to the pot with the dashi, sugar, soy sauce, sake, mirin, and bonito flakes. Cover with parchment paper, and cook over low heat for 30 to 40 minutes.
[5] Check that the squash is fully cooked. Remove from the heat and set aside to cool in the broth.
[6] Serve the squash with a bit of the cooking juices.

Serves 4 Preparation 10 min Cooking 30 to 40 min

Kabocha No Nimono

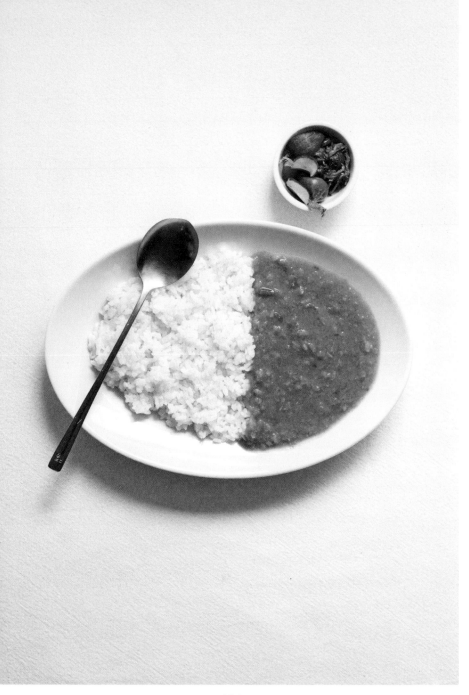

yellow onion [1] garlic [1 clove]

ginger [1 (4-inch) piece] butter [1 tablespoon]

curry roux [2 squares]

peanut butter [1 tablespoon]

miso paste [1 teaspoon] red lentils [½ cup]

soy sauce [1 tablespoon]

cooked japanese rice [1 ⅔ cups]
(see recipe p. 109)

[1] Finely chop the yellow onion and the garlic. Peel and grate the ginger.

[2] In a pot, sauté the onion and garlic in the butter, then add the curry roux, ginger, peanut butter, miso paste, and lentils. Continue to sauté for a few minutes.

[3] Add hot water to cover, and season with the soy sauce. Stir well, and simmer over low heat for 20 minutes. Serve with 1 ⅔ cups of cooked Japanese white rice (see recipe p. 109).

Serves 2 Preparation 10 min Cooking 25 min

Red Lentil Japanese Curry

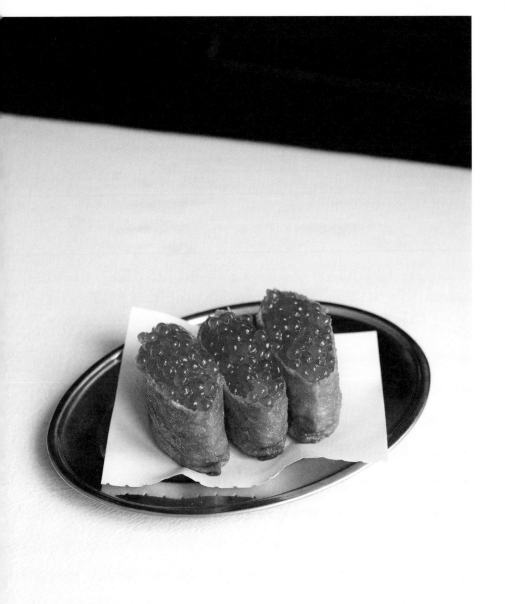

vinegar-seasoned japanese rice^{1⅔ cups}^(see recipe p. 109) sesame seeds^{1 teaspoon} wasabi^{1 teaspoon} inari age⁶ salmon roe^{3 ounces}

[1] Make the seasoned Japanese rice in advance (see recipe p. 109).
[2] Add the sesame seeds and wasabi to the rice.
[3] Open each inari age (fried tofu pockets) and fill with a ball of rice.
 Place the salmon roe on top. Serve immediately.

Makes 6 inari sushi Preparation 10 min

Inari Sushi with Salmon Roe

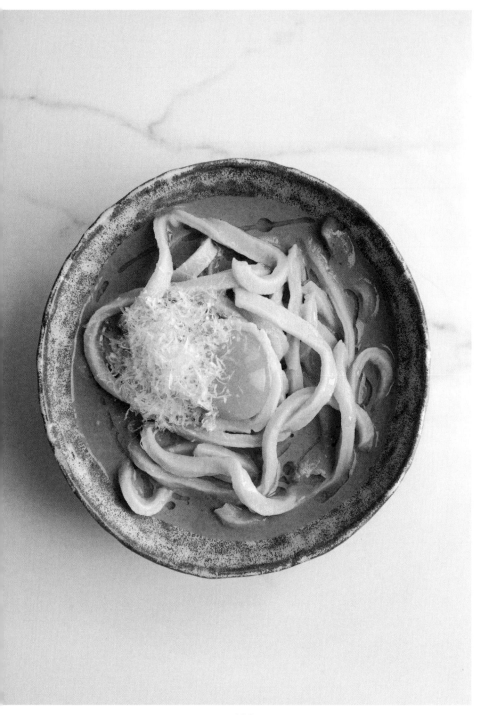

Dough
(for 3 ½ ounces) **OO flour** 1 ⅛ cups **salt** 1 pinch

Watercress purée

watercress 1 (7-ounce) bunch **butter** 1 ¾ sticks
grated parmesan 2 cups
egg yolks 2

Make the dough

[1] In a mixing bowl, combine the flour and the salt with 2 ½ cups hot water
and knead by hand for 10 minutes, or until the dough is smooth and firm.
Form a dough ball, cover with plastic wrap, and rest at room temperature
for 1 hour.

[2] On a floured work surface, roll out the dough ⅟₁₆ inch thick. Cut noodles
⅛ inch wide, and toss with flour to ensure the noodles don't stick together.

Make the watercress purée

[3] Wash the watercress and pick through the leaves. Sauté in a bit of the
butter, then add the rest of the butter to the pan.

[4] Transfer the watercress mixture to a blender, and add ⅓ cup hot water.
Blend until you get a thick, smooth cream. Season with salt and pepper.

[5] Transfer the mixture to a saucepan, and cook over low heat for
2 minutes.

[6] Bring a large pot of water to a boil. Cook the noodles for about 10 minutes,
then drain and rinse under cold water to stop the cooking.

[7] Pour the watercress cream into soup plates and add half of the noodles
and half of the Parmesan to each, plus 1 raw egg yolk per person in the
center. Serve immediately.

Serves 2 Preparation 10 min Cooking 15 min Rest 1 hour

Watercress Udon Noodles

Dough
(for 3 ½ ounces) **00 flour** ^{1 ⅛ cups} **salt** ^{1 pinch}

Cacio e sansho sauce

black peppercorns ^{1 teaspoon}
sansho peppercorns ^{1 teaspoon}
parmesan rind
parmesan ^{1 ounce}
grated pecorino romano ^{heaping ⅔ cup}

Make the dough

[1] In a mixing bowl, combine the flour and the salt with 2 ½ cups hot water and knead by hand for 10 minutes, or until the dough is smooth and firm. Form a dough ball, cover with plastic wrap, and rest at room temperature for 1 hour.

[2] On a floured work surface, roll out the dough ¹⁄₁₆ inch thick. Cut noodles ⅛ inch wide, and toss with flour to ensure the noodles don't stick together.

[3] Bring a large pot of water to a boil. Cook the noodles for 9 minutes, then transfer the noodles to a bowl. Reserve all of the cooking water.

Make the cacio e sansho sauce

[4] Crush the black and sansho peppercorns in a mortar.

[5] Toast the crushed peppers in a dry pan for 1 minute. Add a ladleful of pasta cooking water and the rind of Parmesan. Infuse water with the peppers over low heat.

[6] After about 6 minutes, remove the rind of Parmesan from the pan and add the udon. As with a risotto, add cooking water and stir to help the noodles release their starch. This will emulsify the sauce and make it rich and creamy. Add the Parmesan and pecorino bit by bit, as well as cooking water as needed, stirring all the while. Serve immediately.

Serves 2 Preparation 30 min Cooking 20 min Rest 1 hour

Cacio e Sansho Udon

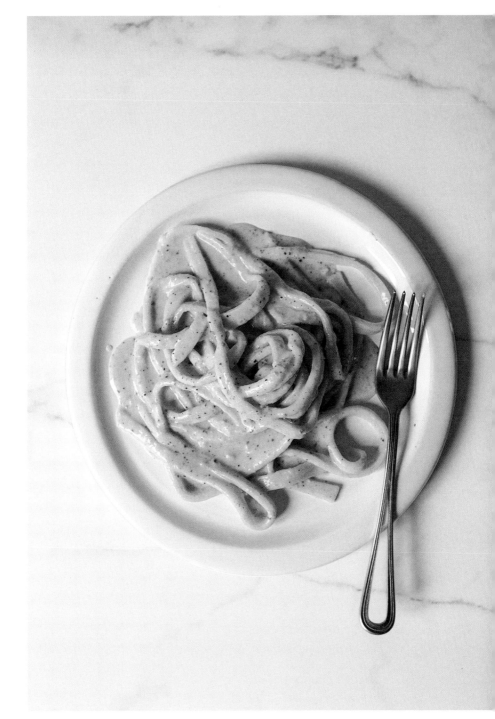

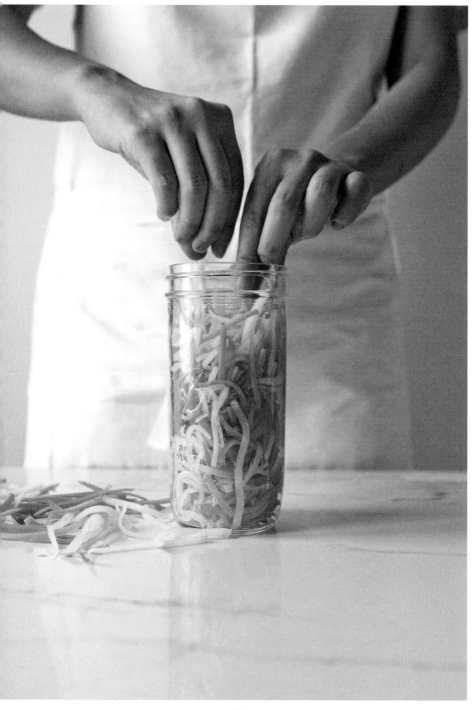

sugar ½ cup

rice wine vinegar ¾ cup + 1 ½ tablespoons

salt 2 pinches carrot 1

daikon radish ½ garlic 2 cloves

bird's-eye chile 1 (optional)

[1] In a small saucepan, heat the sugar, vinegar, and salt in 1 ¼ cups water over low heat. Stir until the sugar has dissolved and the liquid is clear.

[2] Peel and julienne the vegetables, and place in the glass jar. Chop the garlic and slice the chile, if using. Add both to the jar. Pour the warm or cool vinegar mixture over the vegetables so that they are completely covered.

[3] Let sit at room temperature for a few hours, then chill overnight in the fridge. The do chua will be ready to enjoy the next day. Once opened, store in the fridge.

Do chua can be used in banh mi (see recipes p. 145 and 151), as well as served with grilled meat or caramelized pork.

For 1 (17-ounce) hermetically sealed glass jar
Preparation 10 min Rest 1 night Keeps 1 month

Do Chua
(Vietnamese Pickles)

mineral water 2 ⅛ cups

dried mushrooms ¼ cup

soy sauce 4 tablespoons salt 1 teaspoon

kombu 1 sheet bonito flakes ¾ cup

mushrooms 1 (4-ounce) can

rice vinegar 1 tablespoon

sesame oil 1 drop

dried soba noodles 2 (3 ½-ounce) portions

scallions 4 ginger 1 (⅖-inch) piece

sansho peppercorns 1 teaspoon

[1] Pour the water into a saucepan. Add the dried mushrooms, 3 tablespoons of the soy sauce, the salt, kombu, and bonito flakes. Cook over low heat for 15 minutes. Remove the dried mushrooms, strain the broth, and set aside.

[2] Drain the canned mushrooms and rinse them. Mix with 1 tablespoon soy sauce, the rice vinegar, and the sesame oil in a small bowl.

[3] Bring a large pot of water to a boil. Cook the noodles for 3 to 4 min, then drain. Thinly slice the scallions and julienne the ginger. Crush the sansho peppercorns in a mortar.

[4] Serve the noodles in individual bowls. Pour the mushroom broth over the noodles, add the dried and brined mushrooms, as well as the scallion, a bit of sansho pepper, and the ginger. Serve.

Serves 2 Preparation 20 min Cooking 20 min

Soba Noodles with Dried Mushrooms

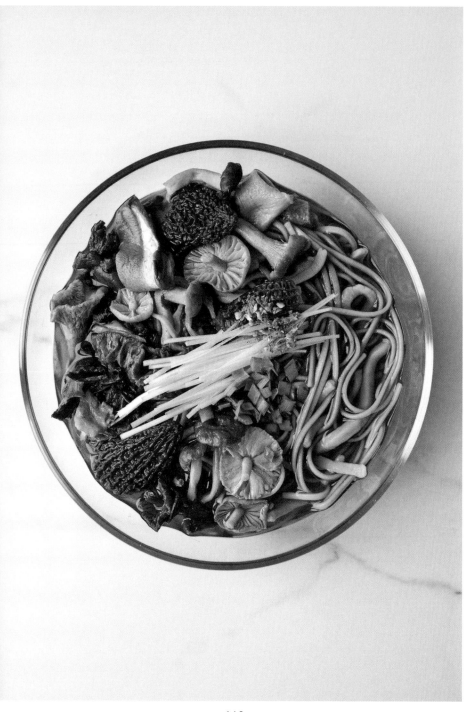

medium rice paper sheets [4]
garlic [1 clove] eggs [2]
sunflower oil [3 tablespoons + 1 drop]

———

Sweet nuoc mam sauce

cilantro [6 sprigs]
sugar [2 tablespoons] nuoc mam [2 tablespoons]
rice vinegar [2 tablespoons]
bird's-eye chile [1 (optional)]

———

[1] Soak the rice paper in water, and stick them together in pairs. Immerse them in water completely for 25 minutes.

[2] Finely chop the garlic and fry in 3 tablespoons oil until golden and crisp. Set the garlic with its oil aside.

[3] Grease a plate with 1 drop of oil, and place a rice paper pair on it. Break an egg in the center, and seal by folding the edges toward the center to make a square.

[4] In a steam cooker, cook the dumplings over low heat for 5 minutes. Do the same with the other rice paper pair.

Prepare the sweet nuoc mam sauce

[5] Chop the cilantro and slice the bird's-eye chile, if using. Stir the sugar, nuoc mam, and rice vinegar in a bowl with the cilantro, chile, if using, and 6 tablespoons water.

[6] Pour the sauce over each banh cuon trung, and drizzle with the fried garlic and oil. Serve immediately.

Serves 2 Preparation 35 min Cooking 10 min

Egg Banh Cuon Trung

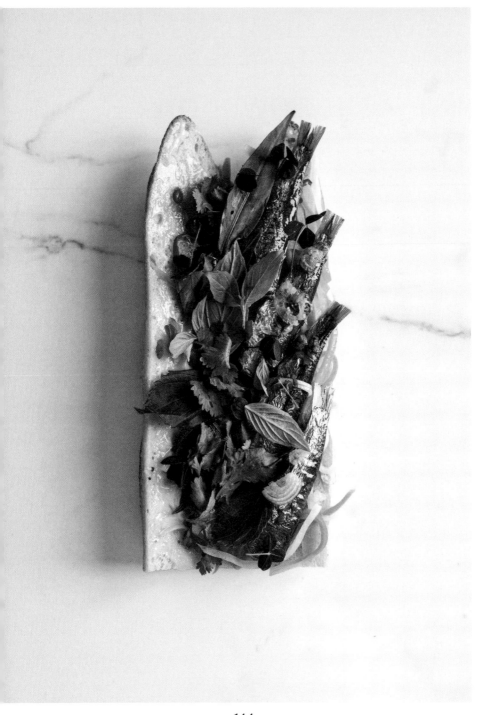

shallot [1] bird's-eye chile [1]
cilantro [3 sprigs] lime [1]
oil-packed sardines [2 (4.2-ounce) cans]
nuoc mam [1 tablespoon] sugar [1 teaspoon]

baguette [1]
maggi sauce [2 tablespoons]
mayonnaise [3 tablespoons]
do chua [3 ½ ounces] (see recipe p. 137)
fresh herbs [(your choice, optional)]

[1] Chop the shallot, chile, and the cilantro. Zest the lime and set aside.
[2] Place the sardines in a dish and cover with nuoc mam, 2 tablespoons lime juice, and sugar. Add the shallot, chile, cilantro, and lime zest. Cover and chill at least 1 hour (or, ideally, overnight).
[3] Halve the baguette and split each half lengthwise. Add a few drops of Maggi sauce to each piece of bread. Spread each side with the mayonnaise, and add the Vietnamese pickles (do chua, see recipe p. 137) and whole sardines. Garnish with fresh herbs of your choice, if using.

Makes 2 banh mi Preparation 20 min Rest 1 night (recommended)

My Mom's Canned Sardine Banh Mi

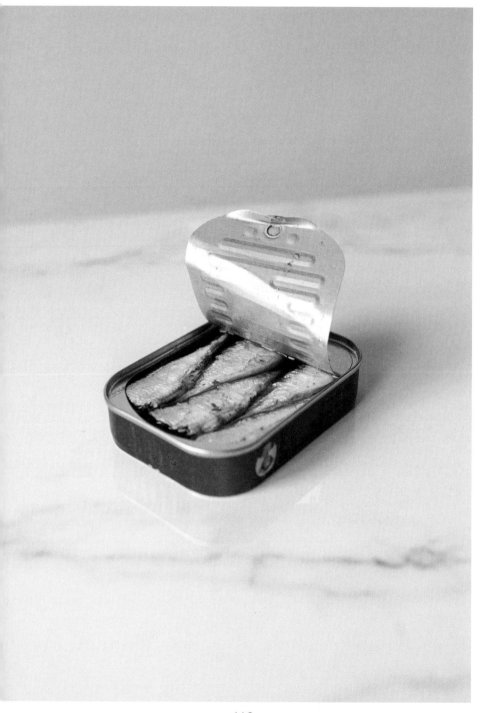

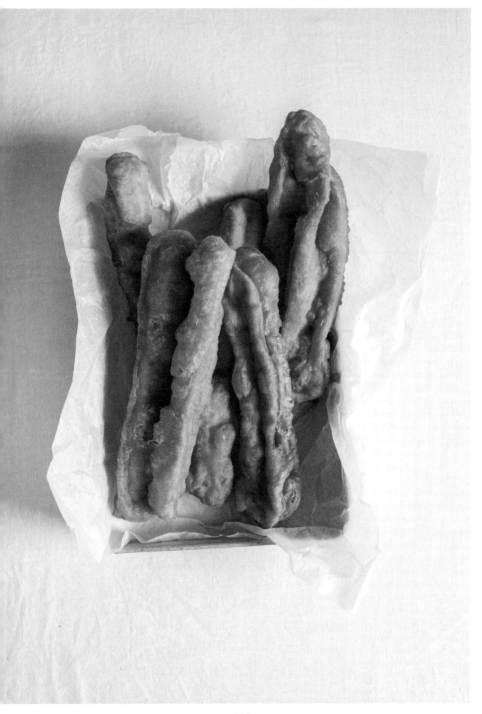

active dry yeast ^{1½ teaspoons}
2% milk ^{½ cup}
high-gluten flour ^{1⅔ cups}
sugar ^{2½ teaspoons} baking soda ^{½ teaspoon}
vegetable oil ^{1 tablespoon + 1 cup}

[1] Dissolve the yeast in a bit of warm milk. Set aside to rest for 10 minutes.

[2] In a large mixing bowl, combine the flour and the sugar. Incorporate the milk-yeast mixture bit by bit, stirring with a pair of chopsticks or with a rubber spatula.

[3] Knead the dough for 12 minutes, or until the dough is firm but still tender. Cover with a damp dish towel, and set the dough aside to rise at room temperature for 1 to 1 ½ hours.

[4] When the dough has tripled in volume, add the baking soda and knead once more for 8 minutes. The dough should be a bit stickier.

[5] Set the dough aside to rise once more at room temperature for 30 minutes to an hour.

[6] Turn the dough out onto a work surface greased with 1 tablespoon of oil. Roll out to a rectangle 1⁄16 inch thick. Cut the rectangle into 12 strips 1 ½ inches wide. Stack the strips two by two, and using a chopstick (or another long, thin object), press down on the middle of the dough strip to create a long, thin, lengthwise mark.

[7] In a heavy-bottomed pot, heat 1 cup oil to 350ºF. Fry the youtiao for 30 seconds max. Turn constantly to ensure they brown evenly.

[8] Drain the doughnuts well on paper towels, and serve immediately.

Makes 6 youtiao Preparation 30 min
Cooking 30 sec Rest 1 hour 30 min to 2 hours 30 min
Youtiao Doughnut Sticks

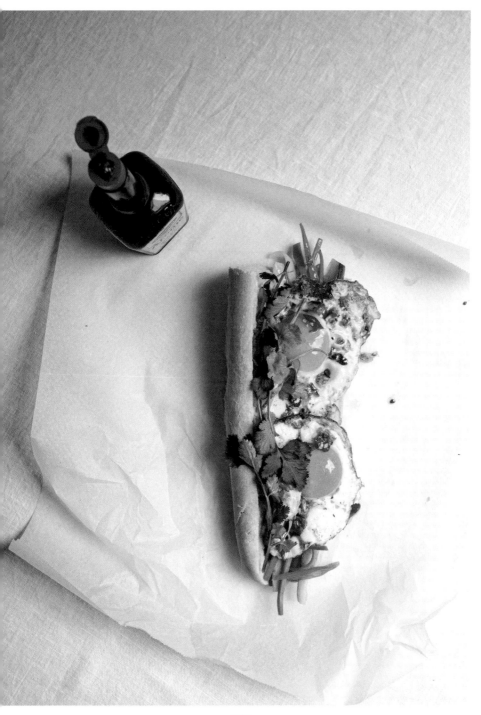

garlic [1 clove] sunflower oil [4 tablespoons, divided]

cucumber [1] eggs [4]

baguette [1]

mayonnaise [1 tablespoon]

do chua [3 ½ ounces (see recipe p. 137)]

cilantro [1 bunch]

Maggi sauce [1 tablespoon]

bird's-eye chile [1 (optional)]

[1] Finely chop the garlic and fry in 1 tablespoon of oil until golden and crisp. Set aside in a bowl.

[2] Cut the cucumber into batons, and remove the seeds. Slice the bird's-eye chile, if using.

[3] Fry the eggs sunny-side up in the remaining 3 tablespoons of olive oil.

[4] Halve the baguette and split each half lengthwise. Spread each side with the mayonnaise. Add the Vietnamese pickles (do chua, see recipe p. 137) and a bit of cucumber. Arrange 2 eggs on each baguette half. Garnish with whole cilantro. Just before serving, season with Maggi sauce, the fried garlic, and bird's-eye chile, if using.

Serves 2 Preparation 10 min Cooking 10 min

Banh Mi Trung

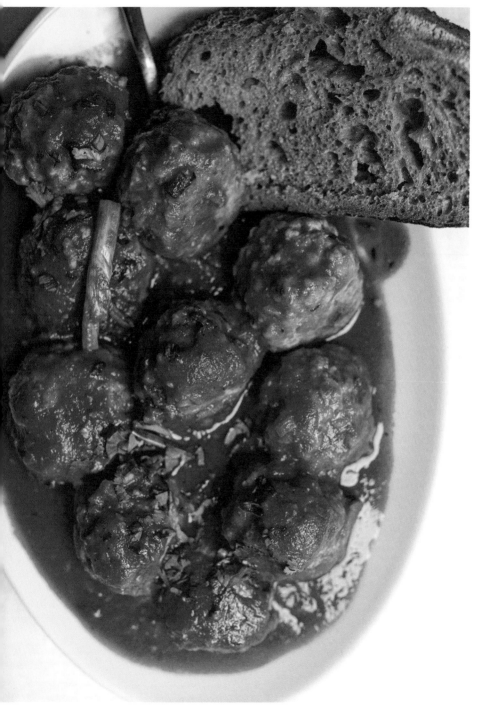

Meatballs

shallot [1]
garlic [1 clove]
sausage meat [14 ounces]
cornstarch [1 tablespoon]
nuoc mam [1 tablespoon]
sesame oil [1 teaspoon] sugar [1 tablespoon]
white pepper [1 teaspoon] salt [1 teaspoon]

optional: oyster sauce 1 tablespoon

━━━━━━━

Tomato sauce

yellow onion [1]
olive oil [1 tablespoon] garlic [1 clove]
peeled tomatoes [1 (28-ounce) can]
cilantro [2 sprigs] scallion [1]
nuoc mam [2 tablespoons]
soy sauce [1 tablespoon] sugar [1 tablespoon]
white pepper [1 teaspoon]

━━━━━━━

bread [4 slices]

━━━━━━━

Serves 4 Preparation 20 min Cooking 1 hour 20 min

Banh Mi Xiu Mai

Make the meatballs
[1] Chop the shallot and the garlic.
[2] In a large mixing bowl, add the shallot and garlic with the sausage meat,
 cornstarch, nuoc mam, sesame oil, and sugar. Season with white pepper
 and salt. Mix by hand until all of the ingredients are well combined.
[3] Make about 10 small meatballs (about 2 to 3 ounces each) and set aside in
 the fridge.

Make the tomato sauce
[4] Finely chop the onion and sauté in a saucepan for about 2 minutes in
 1 tablespoon olive oil. Chop the garlic and add it to the saucepan, sauteing
 1 minute more. Add the peeled tomatoes with their juice, and cook over
 low heat for 20 minutes.
[5] Chop the cilantro and scallion, then add them with the nuoc mam, soy
 sauce and sugar. Season with pepper and cook, covered, over low heat for
 about 40 minutes. Set aside.
[6] In a steam cooker, cook the meatballs over low heat for about 5 minutes,
 to keep them whole. Add them to the sauce, and continue cooking over
 low heat for 15 minutes.
[7] Serve with bread and a bit of chopped cilantro.

Serves 4 Preparation 20 min Cooking 1 hour 20 min

Banh Mi Xiu Mai

dashi ^{2 ⅛ cups (see recipe p. 161)}

kudzu starch ^{⅔ cup}

peanut butter ^{5 tablespoons} salt ^{1 teaspoon}

ginger ^{1 (1 ½-inch) piece} scallion ¹

sesame seeds ^{1 teaspoon}

soy sauce ^{1 teaspoon}

[1] Prepare the vegetarian dashi (see recipe p. 161).

[2] In a mixing bowl, sift the kudzu starch. Add the dashi, then add the peanut butter and salt. Whisk until smooth.

[3] Pour the mixture into a saucepan, and let it emulsify over low heat for 10 minutes, until sticky.

[4] Dampen a square mold with water, and pour the mixture in. Tap the mold a few times on the work surface to pop any air bubbles, then cover with a damp dish towel.

[5] Cool at room temperature, then chill 2 hours.

[6] Peel the ginger and grate or julienne, and slice the scallion.

[7] Just before serving, slice the tofu, sprinkle with sesame seeds, and add the ginger, sliced scallion, and a touch of soy sauce.

Serves 2 Preparation 5 min Cooking 10 min Rest 2 hours

Peanut Tofu

eggs [6] garlic [1 clove]
ginger [1 (4-inch) piece]
soy sauce [1 cup] sake [2 ⅛ cups]
mirin [1 cup] sugar [2 tablespoons]
black pepper [1 pinch]

[1] Cook the eggs in boiling water for 7 minutes, then rinse under
cold water to stop the cooking.
[2] Peel and julienne the ginger, and crush the garlic clove separately.
[3] In a bowl, combine the soy sauce, sake, and mirin with the sugar, and stir
until the sugar has dissolved. Season with pepper and add the ginger.
[4] Place the crushed garlic in a glass jar.
[5] Peel the eggs and add to the jar. Pour the marinade over them and close
the jar. Marinate in the fridge for at least 24 hours. Once opened, store in
the fridge and enjoy quickly.

Nitamago can be used in ramens (see recipes p. 161 and p. 167).

Makes 6 eggs Preparation 10 min Marinate 24 hours Keeps 1 week

Nitamago

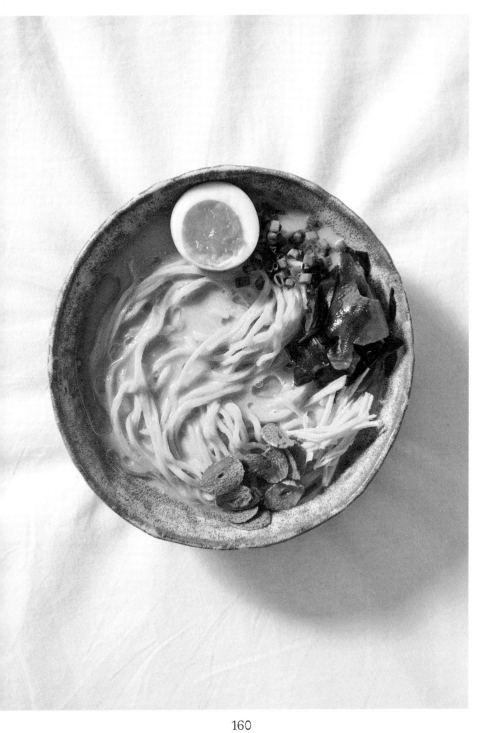

Vegetarian dashi,
(for 1 ¼ cups)

kombu ¹ sheet

dried shiitake
mushrooms ¹ ounce (about 8 pieces)

Soup base

plain soy milk ³ ⅓ cups

soy sauce ² tablespoons

white pepper ¹ teaspoon salt ¹ teaspoon

sake ¹ tablespoon

dried wakame about 2 tablespoons

scallions ² ginger ¹ (4-inch) piece

garlic ² cloves sesame oil ¹ teaspoon

miso ² tablespoons

dried ramen ¹⁴ ounces

nitamago eggs ² (see recipe p. 159)

chile oil ¹ drizzle

Serves 4 Preparation 15 min Cooking 15 min
Soy Milk Ramen

Make the vegetarian dashi
[1] Combine the kombu and the shiitake mushrooms in a saucepan. Add
 1 ⅔ cups water, bring to a boil, then remove from the heat. Infuse until
 cooled.

Make the soup base
[2] In a saucepan, heat the soy milk with the vegetarian dashi. Add the soy
 sauce, pepper, salt, and sake, and cook over low heat for 5 minutes.
 Set aside at room temperature.
[3] Rehydrate the wakame in a bowl of water. Thinly slice the scallions and
 julienne the ginger.
[4] Cut the garlic into thin slices, and fry in a pan in sesame oil until golden
 and crisp.
[5] Whisk the miso into the soy milk broth.
[6] Bring a large pot of water to a boil. Cook the ramen noodles for
 4 to 5 minutes, then drain.
[7] Pour some of the broth and add some of the noodles to each bowl. Add
 the wakame, half a nitamago egg (see recipe p. 159), the scallion, ginger,
 fried garlic, and a bit of the oil used to fry the garlic to each bowl. Serve
 hot with a bit of chile oil.

Serves 4 Preparation 15 min Cooking 15 min
Soy Milk Ramen

163

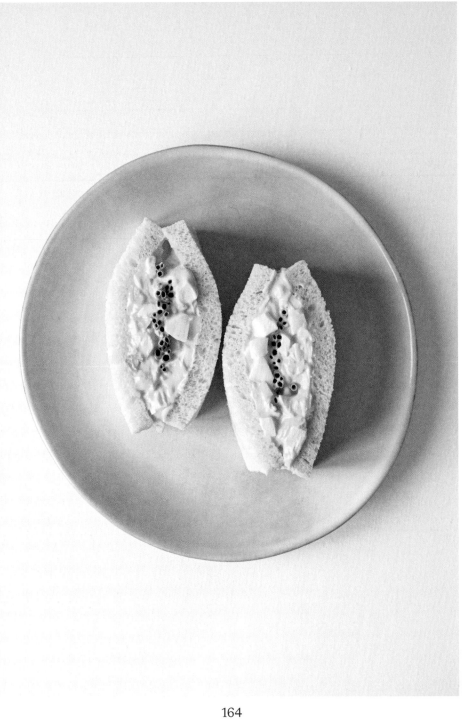

eggs [6] sandwich bread [4 slices]
chives [4 sprigs]

———

Mayonnaise

egg yolk [1] mustard [1 teaspoon]
sunflower oil [2/3 cup]
lemon juice [1 teaspoon]
hot sauce (i.e. Tabasco) 2 tablespoons (optional)

———

[1] In a pot of boiling water, cook the eggs for 10 minutes, then plunge into cold water to stop the cooking. Peel and finely chop. Set aside in a large bowl.

Make the mayonnaise
[2] In a mixing bowl, combine the egg yolk, mustard, and hot sauce, if using. Add the oil bit by bit, whisking to emulsify. Continue until the oil has been completely incorporated. As soon as the mixture thickens, season with salt and pepper and add the lemon juice.
[3] Add 5 heaping tablespoons of the mayonnaise to the chopped eggs and mix to combine.
[4] Cover a bread slice with the egg-mayonnaise mixture. Add the whole chives and cover it with a second thick layer of the egg-mayonnaise mixture. Top with a second slice of bread. Repeat for the second sandwich.
[5] Wrap the sandwiches tightly in plastic wrap. Set aside in the fridge for 30 minutes to make slicing easier.
[6] Remove the sandwiches from the fridge. Trim off the crusts and halve.

Serves 2 Preparation 10 min Cooking 10 min Rest 30 min

Egg Sando

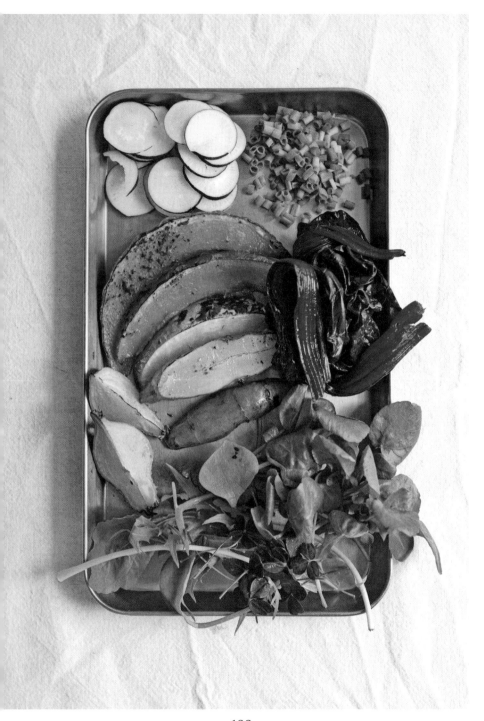

Leek oil

leek green [1]
sunflower oil ¾ cup + 1 ½ tablespoons

Shio tare (ramen sauce)

sugar 1 ¼ teaspoons pink salt 1 tablespoon + 2 teaspoons

coarse sea salt 1 ½ tablespoons

mineral water ¾ cup + 2 tablespoons

rice vinegar 1 ½ teaspoons mirin 1 tablespoon

Broth

winter vegetables 2 ¼ pounds
(pumpkin, carrot, leek, potato, turnip, Jerusalem artichoke...)

ginger 1 (4-inch) piece garlic 1 head

dried shiitake mushrooms [4]

kombu 1 sheet

olive oil 2 tablespoons

leafy greens 1 pound
(spinach, chard, radish tops...)

dry ramen noodles 14 ounces

optional : baby greens, scallion

Serves 4 Preparation 25 min Cooking 2 hours

Winter Vegetable Ramen

Make the leek oil
[1] Blend the leek green with the sunflower oil.
[2] Transfer the mixture to a saucepan. Heat 2 minutes, then strain through
a coffee filter.

Make the shio tare
[3] Mix the sugar and salts in mineral water with rice vinegar and mirin
until dissolved.

Make the broth
[4] Roughly chop two-thirds of the winter vegetables. Place on a roasting
tray and broil until lightly charred.
[5] Place the charred vegetables into a pot, and add water just to cover.
Add the whole ginger, the garlic head halved in two, the dried shiitake
mushrooms, and the kombu. Cook over low heat for 1 hour, then strain
the broth into a bowl. Remove the charred vegetables and place in a dish,
then strain the broth and set aside.
[6] Cut the rest of the winter vegetables into thin slices. Season with salt
and oil, then bake for 20 minutes at 350ºF.
[7] Cook the leafy greens in a pot of salted, boiling water for 2 minutes.
Lift out the greens and place in a bowl; set aside.
[8] Bring a large pot of water to a boil. Cook the ramen noodles for
4 to 5 minutes, then drain.
[9] Place 2 tablespoons of shio tare in each bowl. Pour some of the broth and
add some of the noodles, charred and roasted vegetables, and cooked
leafy greens into each bowl. At the last minute, drizzle a bit of leek oil
over the top, and garnish with baby greens and sliced scallions, if using.

Serves 4 Preparation 25 min Cooking 2 hours

Winter Vegetable Ramen

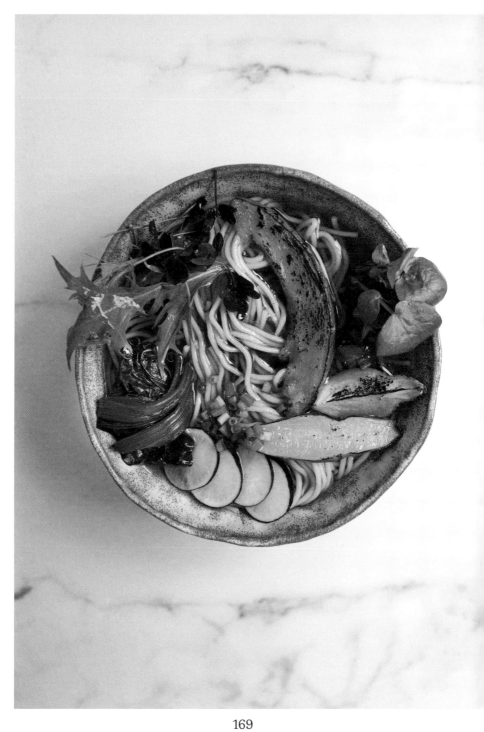

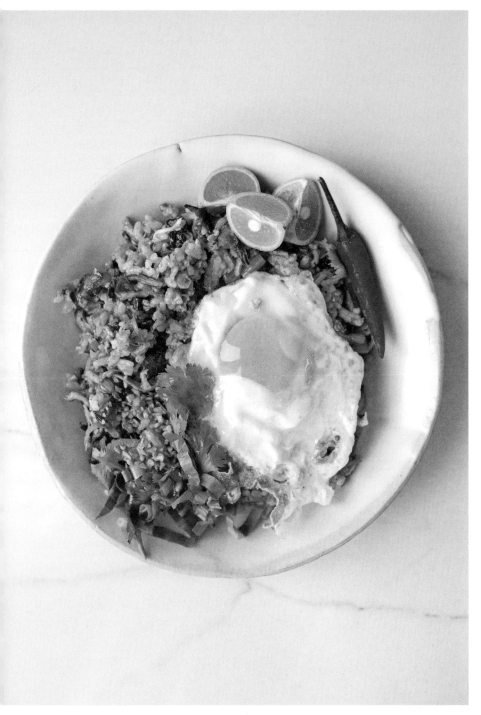

carrot [1] onion [1]

garlic [1 clove] bok choy [2 heads]

sunflower oil [5 tablespoons]

shredded roast chicken [1 heaping cup]

mushrooms [1.7 ounce]

sesame oil [½ teaspoon]

soy sauce [1 tablespoon] nuoc mam [1 tablespoon]

oyster sauce [½ tablespoon] eggs [6]

cilantro [3 sprigs] cooked rice [1 ⅔ cups]

optional: chicken jus 1 tablespoon (see recipe p. 51)

———

[1] Finely dice the carrot and chop the onion and garlic.

[2] In a wok, sauté the carrot and the onion in 1 tablespoon sunflower oil. Add the chicken and the roughly chopped bok choy. Mix well and cook over high heat for 2 minutes. Add the garlic, 1 tablespoon sunflower oil, and the chicken jus, if using, and mix well. Add the whole or sliced mushrooms. Season with sesame oil, soy sauce, nuoc mam, and oyster sauce, and sauté.

[3] Break 2 eggs into the wok, and scramble quickly.

[4] Add the cooked rice, mix well, and sprinkle with some chopped cilantro.

[5] In a pan, fry the other four eggs sunny-side up in the remaining 3 tablespoons of oil.

[6] Serve the rice with 1 fried egg per person and sprinkle with cilantro leaves.

Serves 4 Preparation 10 min Cooking 10 min

Leftover Roast Chicken Fried Rice

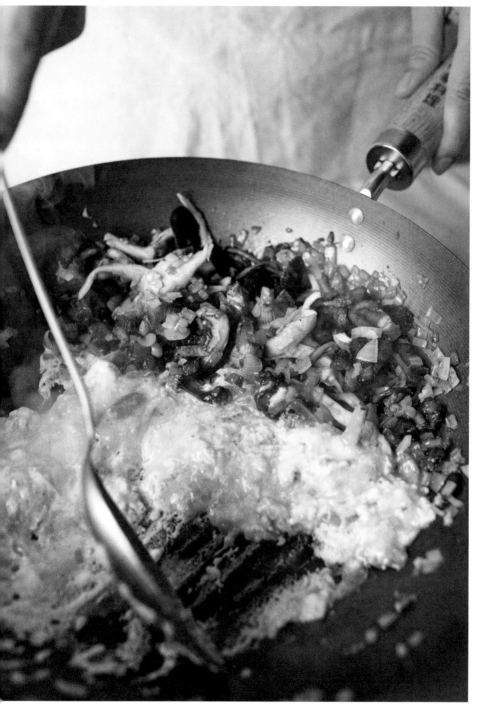

cornstarch [5 tablespoons + 1 teaspoon]

sugar [1 teaspoon]

vegetable broth [6 ⅓ cups]

white asparagus [1 (15-ounce) can]

canned crab meat [7 ounces]

nuoc mam [1 teaspoon]

soy sauce [1 teaspoon] eggs [2]

scallions [2]

white pepper [1 teaspoon]

[1] Dissolve the cornstarch and sugar in 3 tablespoons of water or cold broth.
[2] Heat the vegetable broth in a large pot over medium heat.
[3] Drain the asparagus, and cut into bite-sized pieces. Add to the broth, along with the drained crab. Lower the heat slightly.
[4] Add the nuoc mam, soy sauce, and cornstarch mixture, and continue cooking 5 minutes more.
[5] Beat the eggs in a small bowl, and drizzle into the soup so that the egg mixture creates a cloud within the broth.
[6] Add sliced scallions and season with white pepper. Serve the soup hot.

Serves 4 Preparation 10 min Cooking 20 min

Vietnamese Crab and Asparagus Soup

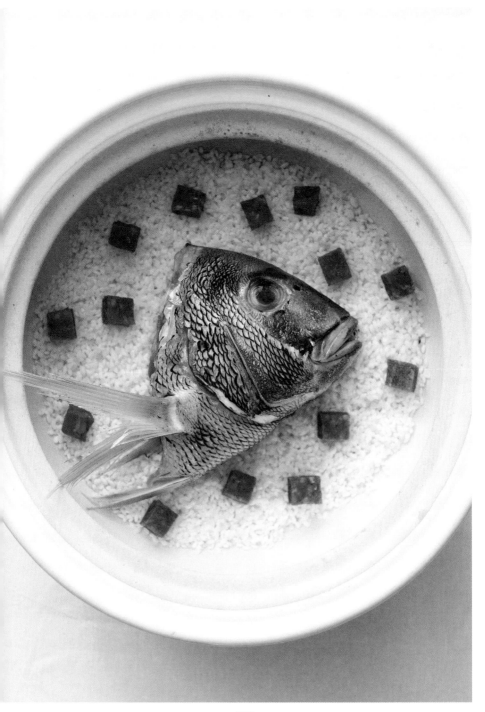

head and spine of pink sea bream [1]

salt [1 tablespoon] soy sauce [½ teaspoon]

kombu [1 sheet] rice [1 scant cup]

iberian cured chorizo [1 ¾ ounces]

[1] Place the fish head and spine on a baking dish and broil 10 minutes.

[2] Separate the head and spine, and cook the spine in 2 ⅛ cups water seasoned with the salt, soy sauce, and kombu over low heat for 30 minutes. Strain the broth into a measuring cup and set aside to cool. Discard the spine.

[3] Wash the rice 6 times in cold water (see steps p. 109), then place in a donabe (Japanese clay pot) or a pot with a lid. Add 1 cup + 1 ½ tablespoons of the broth, the cubed chorizo, and the sea bream head.

[4] Cook, covered, over high heat until the broth comes to a boil. Reduce the heat to low and cook 15 minutes, covered. Remove from the heat and rest 15 minutes, still covered.

[5] Remove as much flesh from the fish head as possible. Mix with the rice and serve immediately.

Serves 2 Preparation 15 min Cooking 55 min Rest 15 min

Sea Bream Head Taimeshi with Chorizo

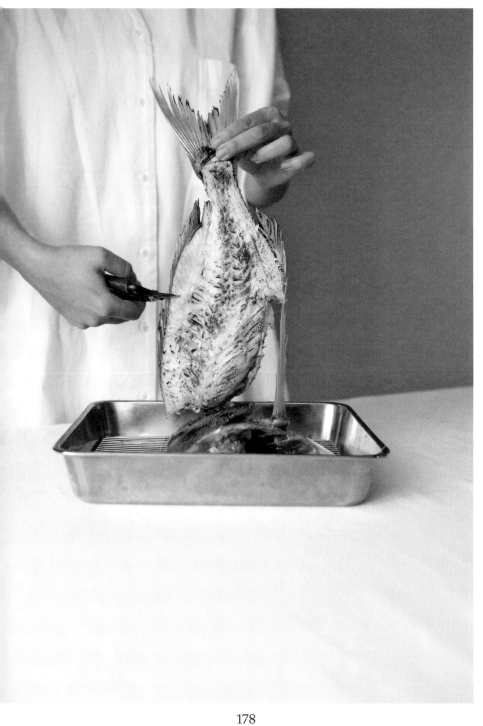

178

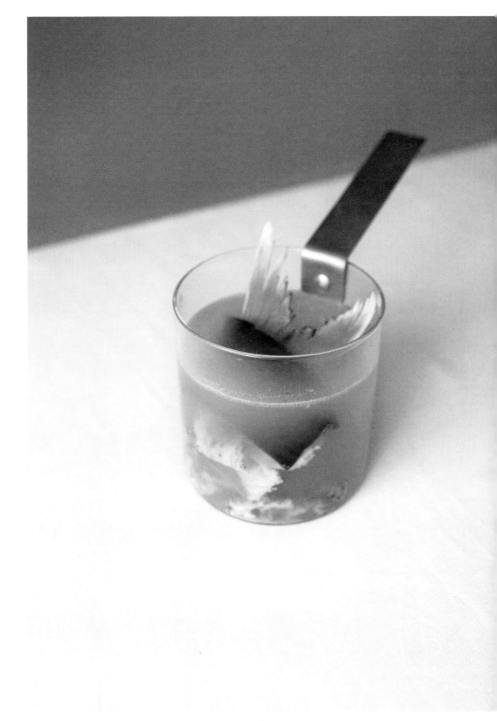

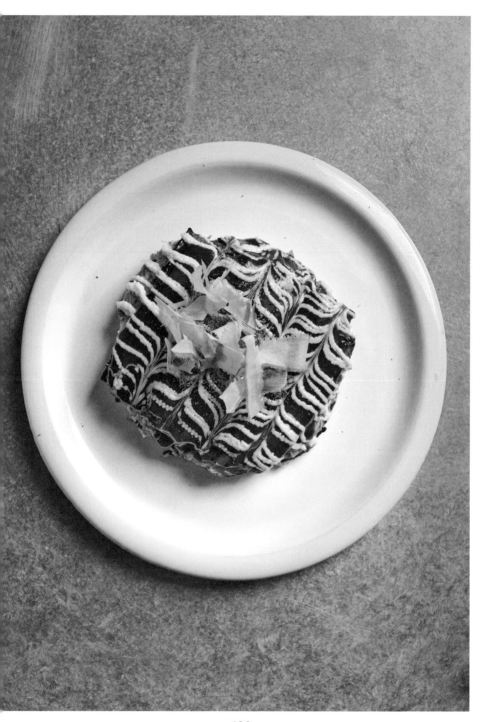

vegetarian dashi 1 ⅓ cups (see recipe p. 161)

flour 2 cups + 6 tablespoons eggs 5

salt 1 teaspoon baking powder 1 teaspoon

sugar 1 teaspoon scallions 2 to 3

white cabbage 1.3 to 1.7 ounces

colonnata lardo 7 ounces

olive oil 3 tablespoons

okonomiyaki sauce 4 tablespoons

japanese mayonnaise 1 teaspoon

aonori 1 teaspoon bonito flakes 2 tablespoons

[1] Prepare the vegatarian dashi (see recipe p. 161).

[2] In a large bowl, combine the flour, dashi, and eggs. Add the salt, baking powder, and sugar.

[3] Chop the scallions and thinly slice the cabbage. Incorporate into the batter. It will be even better if the batter stands at room temperature for 1 hour.

[4] Slice the lardo. Add a ladleful of batter to a well-greased pan, and spread it out lightly without crushing it too much. Arrange the lardo over the top. Cook for a few minutes over low heat, folding the edges toward the center to form a circle. When nicely browned, remove to a plate.

[5] Drizzle with the okonomiyaki sauce and mayonnaise. Use a wooden skewer to marble the sauces together. Garnish with aonori and bonito flakes.

Serves 2 Preparation 15 min Cooking 5 min Rest (optional) 1 hour

Colonnata Lardo Okonomiyaki

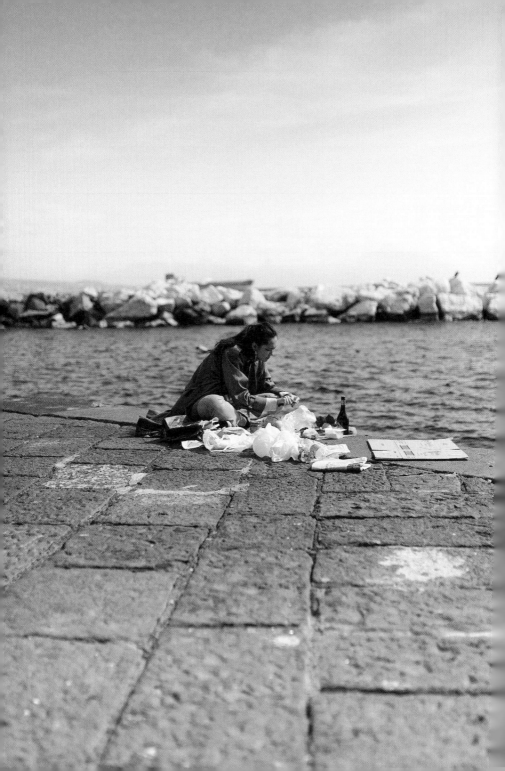

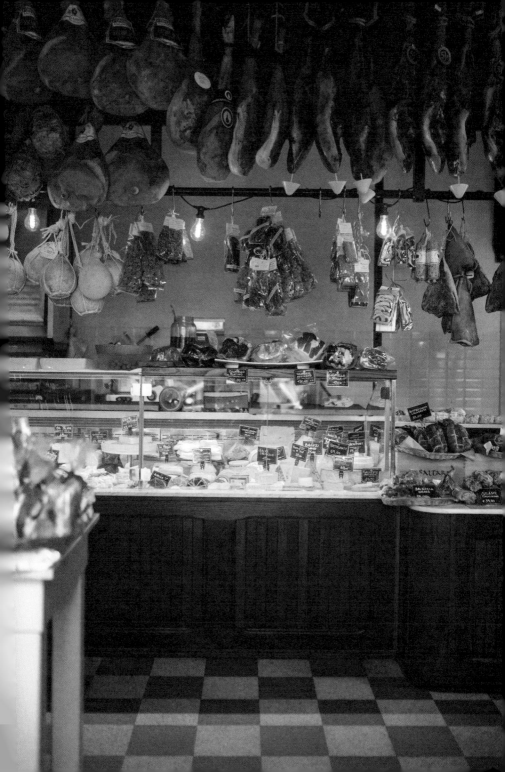

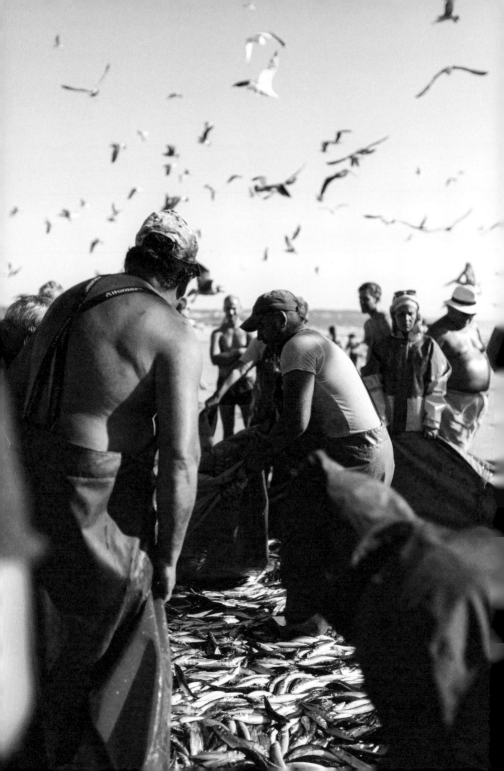

Registro de Calidad
Lata realizada por:
Ana Gómez

ANXOVES
CALLOL SERRATS
DE L'ESCALA

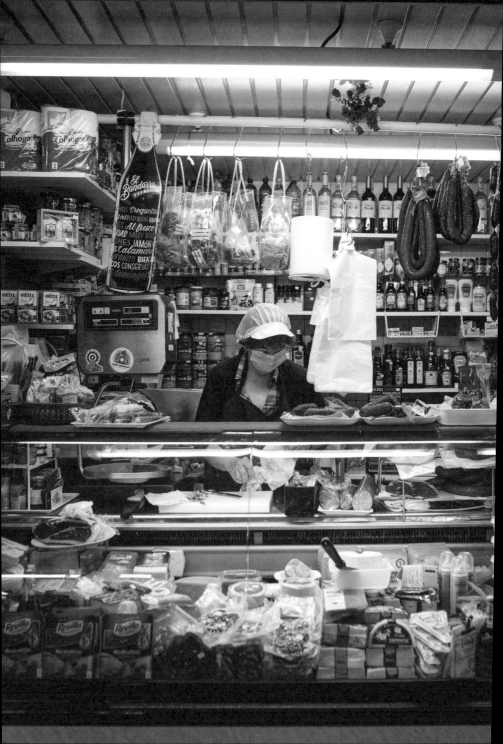

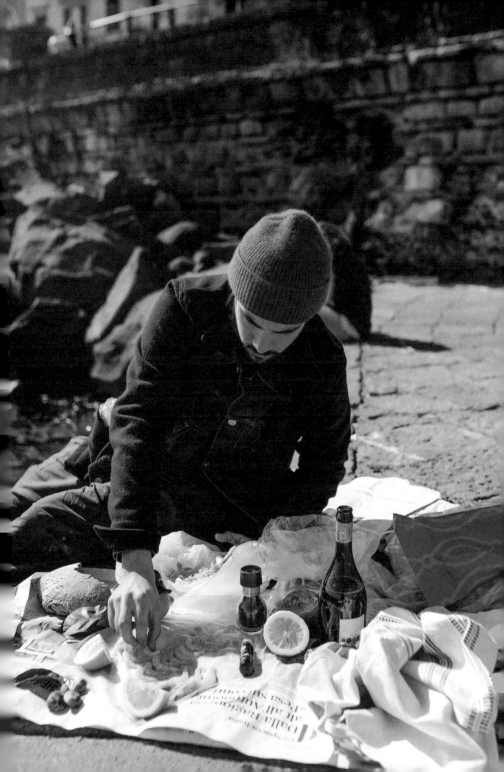

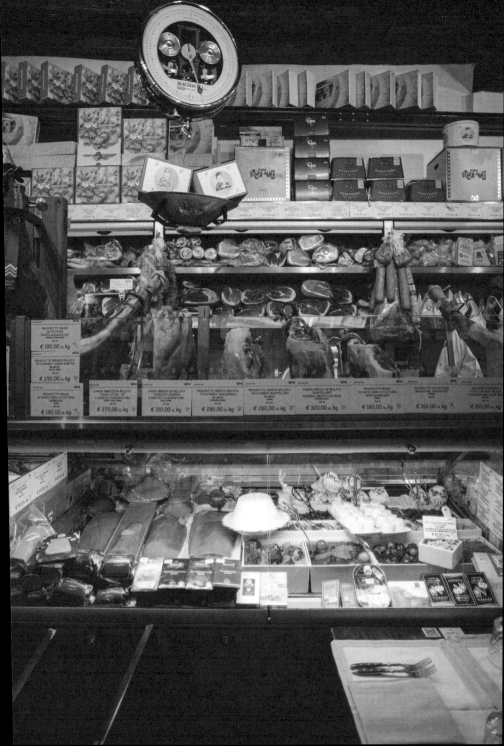

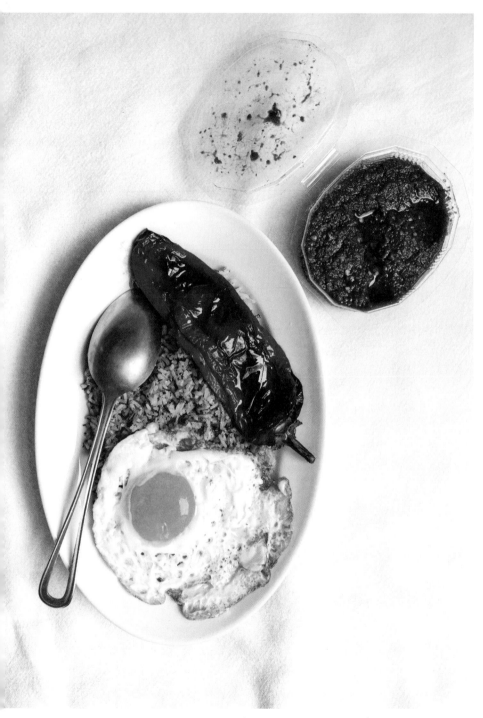

vegetable broth ¾ cup + 1½ tablespoons

spinach 1 ounce shallot 1

garlic 1 clove olive oil 6 tablespoons

jasmine rice 1⅓ cups

herbes de provence 4 tablespoons

butter 2 tablespoons eggs 2

[1] Blend the broth and spinach until smooth.

[2] Chop the shallot and crush the garlic. In a saucepan, sauté the shallot
in 3 tablespoons of olive oil for 2 minutes.

[3] Add the crushed garlic and sauté a minute more. Add the rice and sauté
2 minutes over low heat.

[4] Pour the broth-spinach mixture into the pan, stir for a few minutes,
then add the herbs and reduce the heat to low. Cook, covered, for
15 minutes.

[5] Turn off the heat and rest, covered, for 10 minutes. Add the butter
and stir to combine.

[6] In a pan, heat 3 tablespoons olive oil and fry the eggs sunny-side up.
Place on the rice and serve with fried peppers and harissa, if desired.

Serves 2 Preparation 10 min Cooking 25 min

Grandma's Arroz Verde and Fried Egg

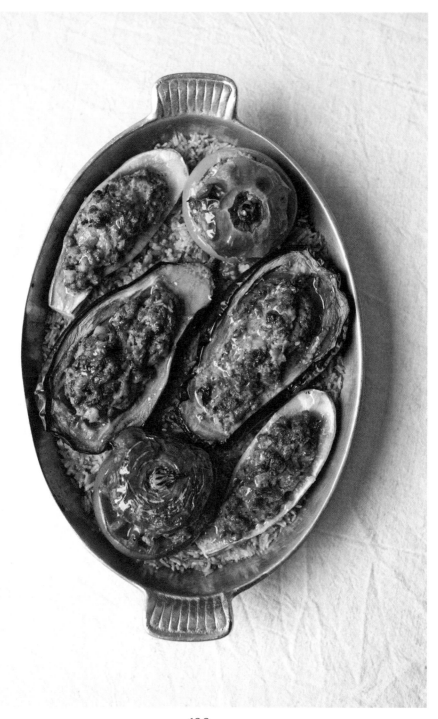

eggplant [2] peppers [2]
zucchini [1] olive oil [3 tablespoons]
tomatoes [4]

Stuffing

cured ham [3 ½ ounces] garlic [1 clove]
rusk [1] milk [2 tablespoons]
sausage meat [10 ½ ounces]
herbes de provence [1 tablespoon]
fennel seeds [1 teaspoon]
nuoc mam [2 tablespoons]

Rice

onion [1] olive oil [1 drizzle]
short-grain rice [1 ½ cups]
saffron [1 pinch] tomato paste [1 tablespoon]
white wine [⅔ cup]
vegetable broth [1 cup]

Serves 4 Preparation 15 min Cooking 1 hour 15 min
Mom's Stuffed Vegetables

[1] Cut the eggplant, peppers, and zucchini in half. Scrape out the seeds, and drizzle with olive oil. Bake at 350°F for 20 minutes. Remove the seeds from the tomatoes and set aside.

Make the stuffing
[2] Chop the cured ham and garlic.
[3] In a large mixing bowl, rehydrate the rusk in enough milk to soften. Add the ham and the sausage meat, and season with herbes de Provence, fennel seeds, and nuoc mam. Mix by hand until all of the ingredients are well combined.
[4] Stuff the eggplant, peppers, zucchini, and tomatoes with the stuffing.

Make the rice
[5] Finely chop the onion, and cook it down with a drizzle of olive oil in a pot. Add the rice, saffron, and tomato paste. When the onion is translucent, deglaze with white wine, and reduce over medium heat. Add the broth and continue cooking 2 minutes.
[6] Spread the rice out in a baking dish, and arrange the stuffed vegetables over the top. Add the butter cut in small pieces on top of the stuffing. Bake for 40 minutes at 340°F. Serve immediately.

Serves 4 Preparation 15 min Cooking 1 hour 15 min
Mom's Stuffed Vegetables

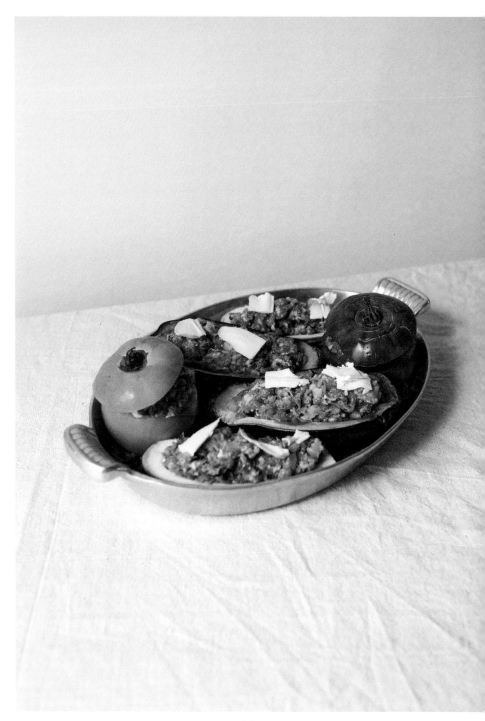

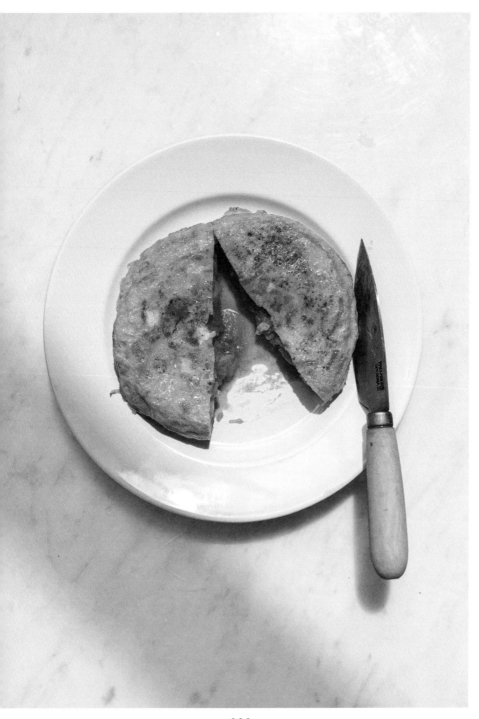

onion ½ olive oil 3 tablespoons
vegetable broth 4 tablespoons
potato chips 1 ½ cups eggs 2

[1] Mince the onion, and sauté in a pan over low heat in 1 tablespoon olive oil. Remove from the heat.
[2] Add the broth and the chips to rehydrate them.
[3] Beat the eggs and add them to the pan.
[4] Grease two smaller pans with 1 tablespoon olive oil each and set them over medium heat. When hot, add the egg mixture to one of them and wait until the edges begin to set. Flip the tortilla into the other pan, and cook about 20 seconds for a gooey tortilla. Serve immediately.

Recipe by chef Sylvain Roucayrol.

Serves 2 Preparation 10 min Cooking 10 min
Potato Chip Tortilla

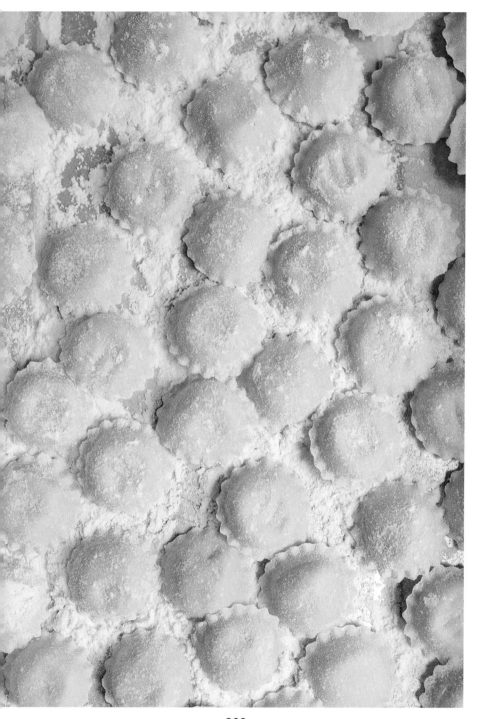

Dough

flour ^{3 ¼ cups} salt ^{2 pinches} eggs ⁵
olive oil ^{2 tablespoons}

shelled walnuts ^{½ cup}

Filling

gorgonzola ^{10 ½ ounces} ^(about 2 cups crumbled)
grated parmesan ^{about 1 cup}
butter ^{7 tablespoons}

Serves 2 Preparation 15 min Cooking 15 min Rest 1 hour

Gorgonzola and Walnut Anolini

[1] Combine the flour and the salt in a bowl, and transfer the mixture to a work surface. Form a well in the center. Crack the eggs into the well, and add the olive oil. Knead until the dough is smooth. Form the dough into a ball, cover in plastic wrap, and set aside to rest at room temperature for 1 hour.

[2] Roughly chop the walnuts, and arrange them on a baking sheet in an even layer. Bake at 350°F for 6 minutes.

[3] Mix the gorgonzola and Parmesan together in a mixing bowl, and season with pepper.

[4] Roll out the dough very thin (about $\frac{1}{32}$ inch). Divide into two pieces.

[5] Place small balls of filling on one of the two pasta sheets, spacing them out about ¼ inch apart. Cover with the other dough half, and cut the anolini with a cookie cutter or anolini cutter.

[6] Bring a large pot of salted water to a boil. Cook the anolini in batches for 1 minute. Drain.

[7] In a small pan, heat the butter over low heat until foamy. As soon as it stops foaming and takes on a golden color, remove from the heat. Add the anolini and toss well in the browned butter, then sprinkle with the toasted walnuts, and serve.

Serves 2 Preparation 15 min Cooking 15 min Rest 1 hour

Gorgonzola and Walnut Anolini

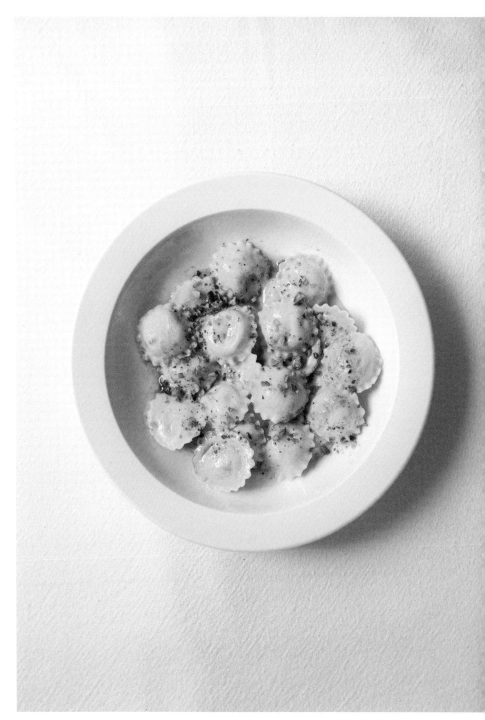

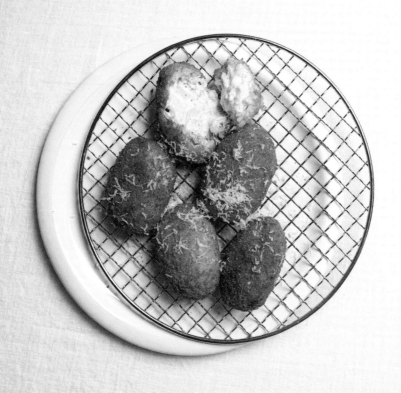

Cacio e pepe cream

butter ³ ½ tablespoons

flour ⁶ ½ tablespoons milk ² ½ cups

black peppercorns ¹ teaspoon

grated pecorino romano ¹ ½ cups

Arancini

yellow onion ½ olive oil ¹ tablespoon

arborio rice ² cups

dry white wine ½ cup

vegetable broth ¹ cup

butter ¹ tablespoon

grated parmesan ¹ cup

flour ¾ cupe eggs ²

breadcrumbs ¹ cup

sunflower oil ¹ ¼ cups

Makes 6 arancini Preparation 30 min Cooking 35 min

Cacio e Pepe Arancini

Make the cacio e pepe cream

[1] Melt the butter in a saucepan. Add the flour and cook, stirring constantly, without browning. Add the milk bit by bit, stirring all the while, until thickened.

[2] Crush the black peppercorns and toast in a dry pan for 1 minute. Add to the cream along with the pecorino and stir to incorporate. Set aside to cool.

Make the arancini

[3] Finely chop the onion. Sauté in the olive oil in a heavy-bottomed saucepan, taking care not to brown. Add the arborio rice and cook over low heat for 2 minutes, until translucent. Add the white wine and a bit of vegetable broth. Reduce, stirring all the while. As soon as the rice has absorbed the broth, add the rest, stirring all the while. When the rice is cooked, add the butter and Parmesan, stir to incorporate, then set aside to cool.

[4] Form the rice into balls, then make a hole with your thumb and pour in a bit of the cacio e pepe cream. Seal the ball.

[5] Pour the flour into a dish, beat the eggs in a second dish, and pour the breadcrumbs into a third. Toss the arancini in the flour, followed by the egg, and finally the breadcrumbs.

[6] In a heavy-bottomed pot, heat the sunflower oil to 350ºF. Fry the arancini until golden brown on all sides. Drain on paper towels and serve immediately.

Makes 6 arancini Preparation 30 min Cooking 35 min

Cacio e Pepe Arancini

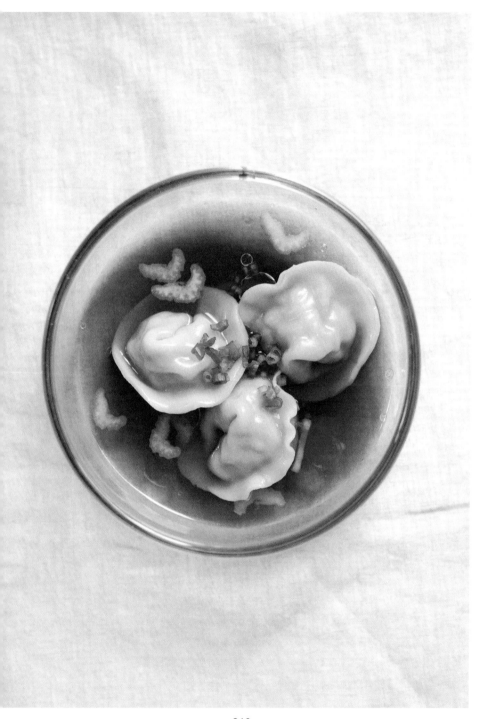

Dough

flour 3 ¼ cups salt 2 pinches
eggs 5 olive oil 2 tablespoons

Broth

yellow onions 4
butter 1 tablespoon sugar ¼ cup
white wine ⅓ cup
vegetable broth ¾ cup + 1 ½ tablespoons
sage 3 leaves

Filling

ricotta ¾ cup + 1 tablespoon egg 1
grated parmesan 1 ¾ tablespoons

celery 1 rib scallions 2

Makes 12 ravioli (serves 4) Preparation 20 min Cooking 1 hour Rest 1 hour

Ricotta Ravioli with Caramelized Onion Broth

Make the dough

[1] Combine the flour and the salt in a bowl, and transfer the mixture to a work surface. Form a well in the center. Crack the eggs into the well, and add the olive oil. Knead until the dough is smooth. Form the dough into a ball, cover in plastic wrap, and set aside to rest at room temperature for 1 hour.

Make the broth

[2] Thinly slice the onions. Cook in a tablespoon of butter in a pan for 10 minutes. When they are golden brown and very soft, add the sugar. Caramelize slowly, on low heat, stirring all the while. When they have taken on a nice caramel color, remove from the heat. Reserve half of the onions for the filling.

[3] Set the remaining onions over high heat, and deglaze the pan with the white wine. Reduce until all of the liquid has cooked off, then add the broth and the sage. Cook over medium heat for 30 minutes, then strain into a measuring cup, discard the solids, and season with salt and pepper. Set aside and keep warm.

Make the filling

[4] In a bowl, combine the remaining caramelized onions with the ricotta, grated Parmesan, and egg. Season to taste with salt and pepper.

[5] Roll out the dough very thin (about $1/32$ inch), and cut out squares using a pasta roller. Place a spoonful of filling in the center, and fold the rectangle over into a triangle, pushing down on the edges to seal them and taking care to press out any air. Wrap the edges of the triangle around your finger to seal and form the ravioli. Dust with flour as you go to ensure the ravioli do not stick to one another.

[6] Bring a large pot of salted water to a boil, and cook the ravioli for 3 to 4 minutes. Drain.

[7] Place 3 ravioli in each plate. Top with sliced celery and pour the onion broth over the top. Sprinkle with sliced scallion before serving.

Makes 12 ravioli (Serves 4) Preparation 20 min Cooking 1 hour Rest 1 hour

Ricotta Ravioli with Caramelized Onion Broth

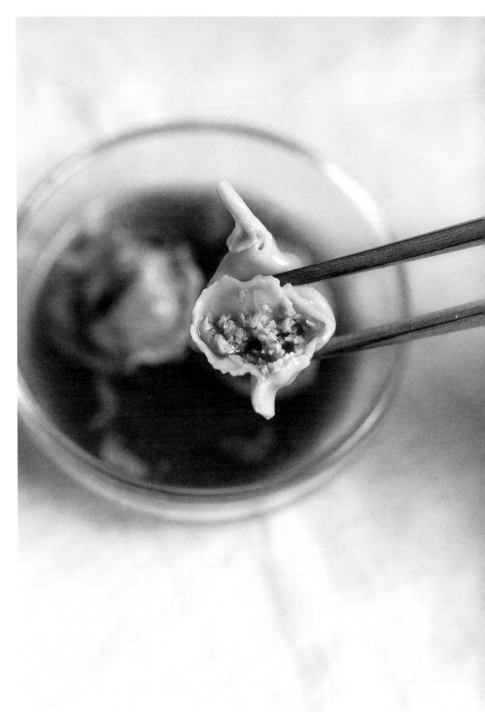

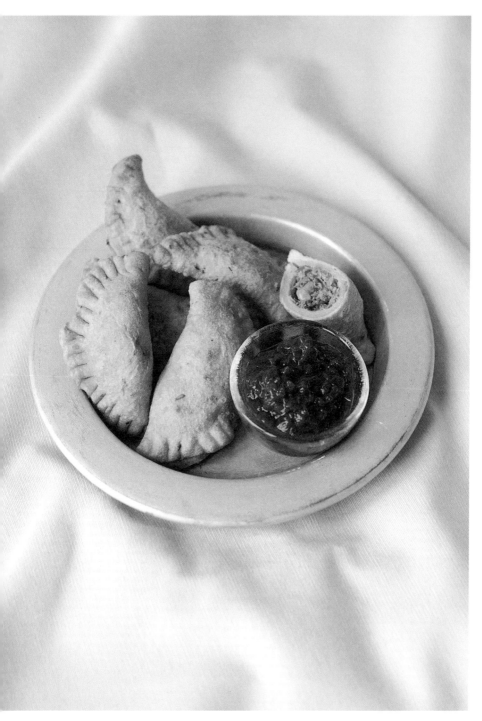

Dough

butter ¾ stick milk ¾ cup + 1 ½ tablespoons
pastry flour 4 cups eggs 2
baking powder 2 ½ teaspoons salt 1 pinch

Sauce

onion 1 garlic 2 cloves
sunflower oil 2 tablespoons
sugar 2 teaspoons tomato paste 2 tablespoons
bouillon cube 1
chile powder 1 teaspoon

Filling

onion 1 red bell pepper 1
sunflower oil 2 tablespoons
mackerel 2 (4 ½-ounce) cans
tomato paste 1 tablespoon
bouillon cube 1
chile powder 1 teaspoon

frying oil

Makes 10 pastels Preparation 30 min Cooking 30 min Rest 1 hour

Mackerel and Chile Pastels

Make the dough

[1] In a saucepan, melt the butter in the milk.

[2] Mix the other dough ingredients in a mixing bowl. Add the butter-milk mixture, and knead until the dough is smooth and even. Cover with a dish towel, and rest at least 1 hour.

Make the sauce

[3] Mince the onion and chop the garlic. Caramelize the onion in a pan with the oil and sugar. Add the tomato paste, bouillon cube, chile, and chopped garlic. Cook over low heat for 1 minute, then add a cup of water.

[4] Cook on low heat for around 20 minutes until thick, then season with salt and pepper.

Make the filling

[5] Mince the onion and pepper, and sauté with 2 tablespoons oil in a pan for 5 minutes, until softened. Remove from the heat.

[6] Break up the mackerel, and, off the heat, add it to the mixture along with the tomato paste, bouillon cube, and chile powder. Season with salt and pepper, and mix well to combine.

Make the pastels

[7] Roll the dough out to $\frac{1}{16}$ inch thick, and cut out 4-inch rounds. Place a tablespoon of filling on one half of each round, and fold over to form half-moons. Press down with a fork to seal.

[8] In a heavy-bottomed pot, heat the oil to 340ºF. Fry the pastels. When they are golden brown, remove and drain on paper towels. Serve the pastels with the sauce.

Makes 10 pastels Preparation 30 min Cooking 30 min Rest 1 hour

Mackerel and Chile Pastels

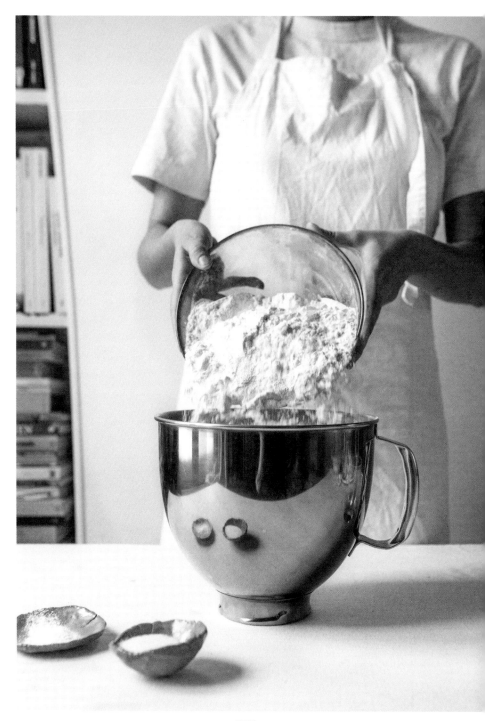

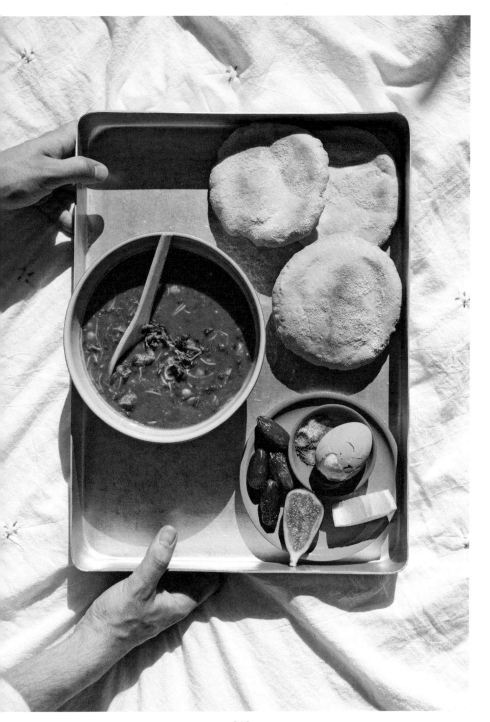

chickpeas ½ cup lentils ⅓ cup

large tomatoes 4 onion 1

celery 1 stalk parsley 1 bunch

cilantro 1 small bunch

lamb collar 1 pound 1 ounce

smen or olive oil 1 tablespoon

ground ginger 2 tablespoons

turmeric 1 tablespoon saffron 1 pinch

cinnamon 1 pinch

tomato paste 1 tablespoon

vermicelli 1 handful

flour 2 to 3 tablespoons

—

Serves 4 Preparation 30 min Cooking 1 hour 30 min Rest 1 night

Harira

[1] The night before, soak the chickpeas and lentils in water. If you have
 time, remove the skin of the chickpeas.
[2] Blend the tomatoes, including the skin and seeds.
[3] Cut the onion, celery, parsley, and cilantro very finely.
[4] Dice the lamb.
[5] In a pot, sauté the onion in the smen or olive oil without browning
 it too much. Add the lamb and sauté it for a few minutes. Add the ginger,
 turmeric, saffron, and cinnamon. Season with salt and pepper, and add
 the parsley and cilantro, celery, chickpeas, and lentils.
[6] Add water to cover, then add the tomato paste and blended tomatoes.
[7] Cover and cook for 1 to 1 ½ hours over low heat. When the lamb is
 cooked, add the noodles.
[8] Make the tedouira, the thickener for the soup. Combine the flour and
 a bit of cold water, then add it to the soup bit by bit, stirring all the while.
 Season to taste as needed.

Serve with hard-boiled eggs, dates, and batbout bread (small Moroccan bread).

Serves 4 Preparation 30 min Cooking 1 hour 30 min Rest 1 night

Harira

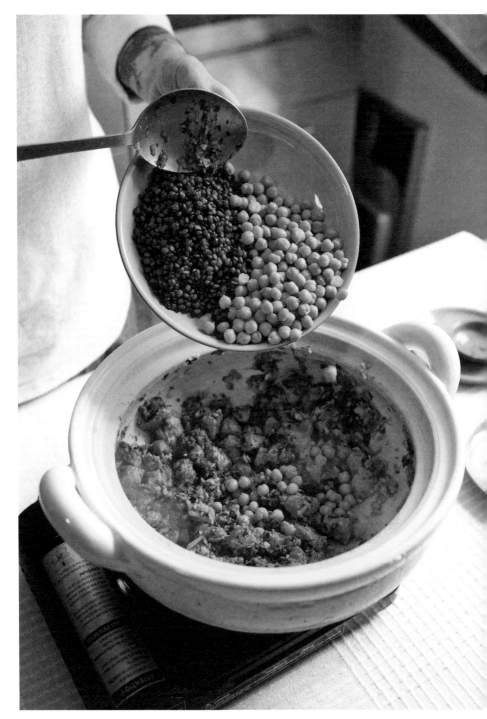

221

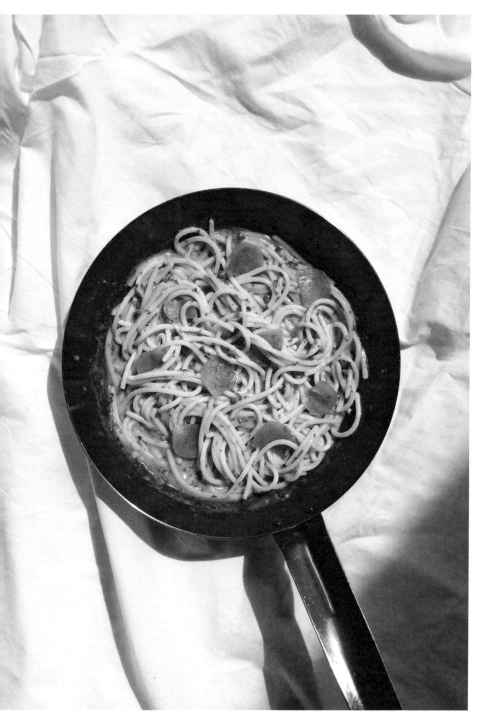

bottarga [2 ounces] parsley [½ bunch]

capers [4 tablespoons + 2 teaspoons]

garlic [1 clove] olive oil [2 tablespoons]

red pepper flakes [1 pinch]

spaghetti [7 ounces]

———

[1] Cut the bottarga into thin slices. Chop the parsley and capers separately, and crush the garlic clove.

[2] In a pan, heat the olive oil with the garlic and red pepper, then add the chopped capers.

[3] Bring a large pot of water to a boil. Cook the spaghetti for 5 to 6 minutes, just before al dente, then drain, reserving a ladleful of cooking water.

[4] Add the pasta and cooking water to the pan. Cook 2 minutes over low heat, until the water has cooked off and the texture is creamy. Add the parsley and stir.

[5] Serve the pasta with thin slices of bottarga over the top.

Serves 2 Preparation 10 min Cooking 15 min

Spaghetti alla Bottarga

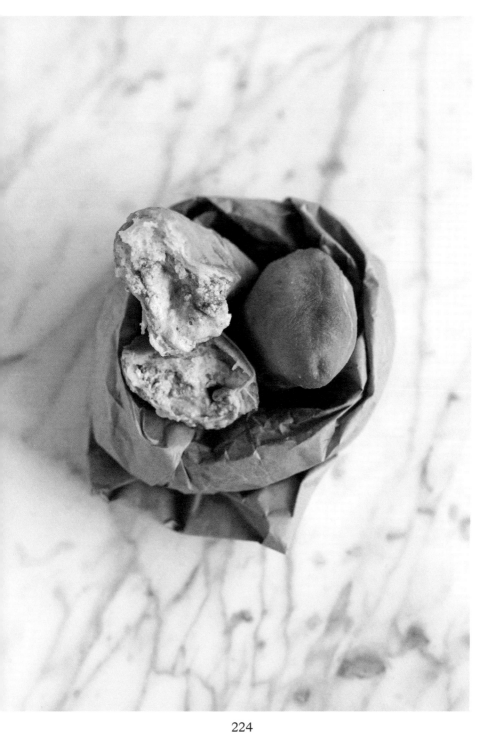

Filling

spinach 6 ⅔ cups

olive oil 1 tablespoon garlic 1 clove

ricotta 1 cup mozzarella 3 ½ ounces

olive oil-packed

artichokes 1 (7-ounce) jar

scamorza 3 ½ ounces (optional)

Dough

active dry yeast 1 tablespoon

pastry flour 4 ⅔ cups

sugar 4 teaspoons salt 1 ¾ teaspoons

olive oil 3 tablespoons + 1 teaspoon

frying oil

Serves 4 Preparation 20 min Cooking 10 to 15 min Rest 2 hours

Fried Dough with Spinach and Artichokes

Make the filling
[1] In a pan, sauté the spinach in olive oil with the crushed clove of garlic for
 5 minutes. Remove the garlic.
[2] Drain the artichokes. Blend the spinach with ricotta, mozzarella,
 scamorza, if using, and artichokes until smooth. Chill until ready to use.

Make the dough
[3] Dissolve the yeast in 1 ⅓ cups cold water. In a mixing bowl, combine the
 pastry flour, sugar, salt, and olive oil, and knead by hand for 10 minutes
 until smooth. Cover with a dish towel and rest 1 hour.
[4] Divide the dough into 4 pieces of about 1 ½ ounces each. Cover with a
 cloth and rest 1 hour.

[5] Dust the work surface with flour, then roll the dough out into rounds
 about ¹⁄₁₆ inch thick with a rolling pin.
[6] Place a tablespoon of filling on one side of each round. Fold over into
 a half-moon, pressing down on the edges to seal well.
[7] In a heavy-bottomed pot, heat the frying oil to 350°F. Fry the pizzas
 until they are nicely golden brown. Drain on paper towels and serve hot.

Serves 4 Preparation 20 min Cooking 10 to 15 min Rest 2 hours

Fried Dough with Spinach and Artichokes

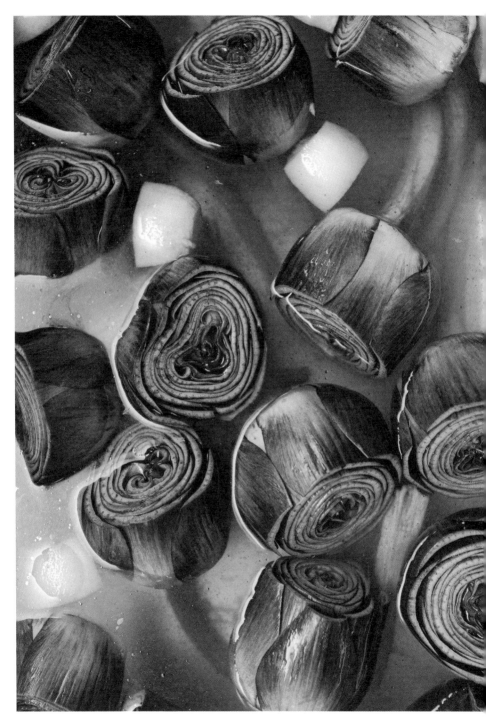

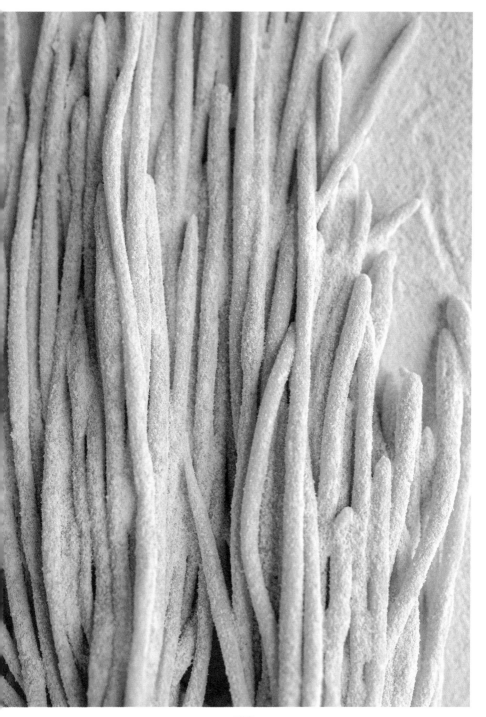

Dough

00 flour 2 ⅓ cups plus more for dusting

salt 2 pinches **fine semolina**

Dressing

olive oil 3 tablespoons + 1 drizzle **garlic** 1 clove

dried chile 1 **breadcrumbs** 1 ½ cups

grated pecorino 2 tablespoons

Make the dough

[1] In a mixing bowl, form a well in the flour. Add ½ cup of warm water and the salt. Knead the dough vigorously until homogenous and elastic. Form the dough into a ball, cover with a dish towel, and rest at room temperature for 30 minutes.

[2] Roll the dough out ⅛ inch thick, dust with flour, and roll up into a long sausage shape, like a jelly roll. Cut ¾-inch-wide rounds with a floured knife. Unroll the rounds into ribbons, and place on a floured work surface. Roll the dough ribbons between your fingertips in order to make long, thick noodles, then roll them out longer on the work surface with your palms, slowly separating your hands as you go to lengthen them. Sprinkle the pici with semolina (or flour) and stretch them out once more. Cover with a dish towel, and set aside.

Make the dressing

[3] Heat the oil in a pan. Crush the garlic clove and the chile, and add to the pan with the breadcrumbs. Cook, stirring frequently, until golden brown.

[4] Bring a large pot of salted water to a boil. Cook the pici for 5 minutes, then drain.

[5] Add the pici to the briciole with a drizzle of olive oil. Cook, stirring frequently, for 2 minutes. Serve with the grated pecorino cheese.

Serves 4 Preparation 30 min Cooking 10 min Rest 30 min

Pici alle Briciole

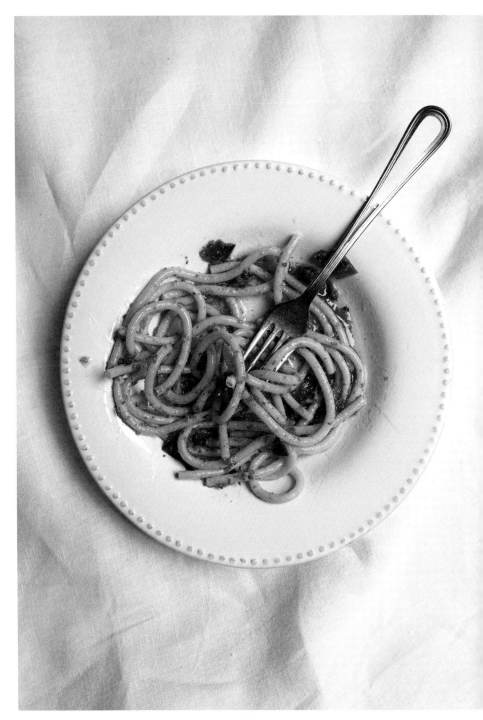

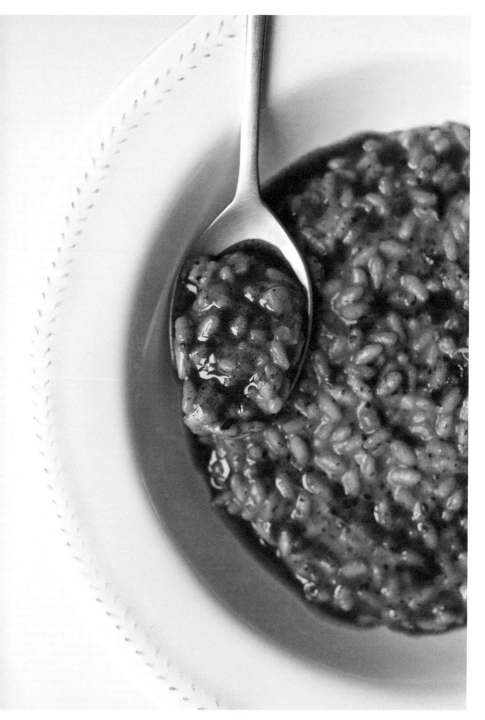

dried mushrooms 1 ¾ ounces (scant ½ cup) (your choice)

vegetable broth 2 ⅛ cups

shallot 1 olive oil 1 drizzle

arborio rice 1 ¼ cups

white wine ⅔ cup

grated parmesan ½ cup

butter 6 tablespoons (divided)

[1] Blend the dried mushrooms until a powder forms. Heat the broth in a pot over low heat.

[2] Mince the shallot and sauté in a pan in the olive oil. Add the rice and cook 2 minutes over medium heat, stirring all the while. Add the mushroom powder, and stir 1 minute, then deglaze with the white wine and reduce by half.

[3] Add a ladleful of broth to the pot, and cook, stirring continuously. As soon as the rice is dry, add another ladleful of broth, and cook 10 minutes over low heat, stirring all the while. When the rice is al dente, remove from the heat.

[4] Add the Parmesan and 3 ½ tablespoons of the butter. Mix well and cover.

[5] In a small pan, heat the rest of the butter over low heat until foamy. As soon as it stops foaming and takes on a golden color, remove from the heat.

[6] Serve the rice drizzled with the browned butter.

Serves 6 Preparation 10 min Cooking 40 min

Dried Mushroom Risotto

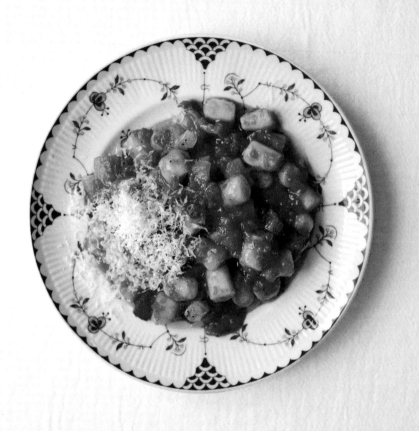

Gnocchi

yukon gold potatoes 1 pound 1 ounce

00 flour 1 ⅛ cups plus more for dusting

olive oil 2 tablespoons salt ½ teaspoon egg 1

———

Amatriciana sauce

guanciale 4 ¼ ounces olive oil 1 drizzle

white wine ⅔ cup

crushed tomatoes 1 (14-ounce) can

crushed red chile 1 pinch

grated pecorino romano 3 ½ ounces (1 cup)

———

Serves 4 Preparation 20 min Cooking 50 min Rest 15 min

Gnocchi all'Amatriciana

Make the gnocchi

[1] Bake the potatoes, skin-on, for 40 minutes at 350ºF. Set aside to cool, then peel the potatoes. Place in a bowl, drizzle with olive oil, and mash into a smooth purée using a potato masher.

[2] Add the flour, salt, and egg, and mix well until you have a thick dough.

[3] On a floured work surface, form long ropes of dough about 1 inch wide. Cut into ¾-inch lengths, sprinkle with flour, and set on a floured dish towel, taking care to ensure they don't touch. Rest 15 minutes.

Make the amatriciana sauce

[4] Cut the guanciale into thin strips. Sauté in a pan in a drizzle of olive oil until the fat becomes transparent and slightly golden. Deglaze with the white wine, and remove the guanciale from the pan.

[5] Add the crushed tomatoes and chile to the pan. Simmer for about 15 minutes, then return the guanciale to the pan and simmer 10 minutes more, stirring from time to time.

[6] Bring a large pot of water to a boil. Cook the gnocchi until they come to the surface, then drain, reserving the cooking water. Add 1 to 2 ladles of cooking water to the sauce along with the drained gnocchi. Serve with the grated pecorino.

Serves 4 Preparation 20 min Cooking 50 min Rest 15 min

Gnocchi all'Amatriciana

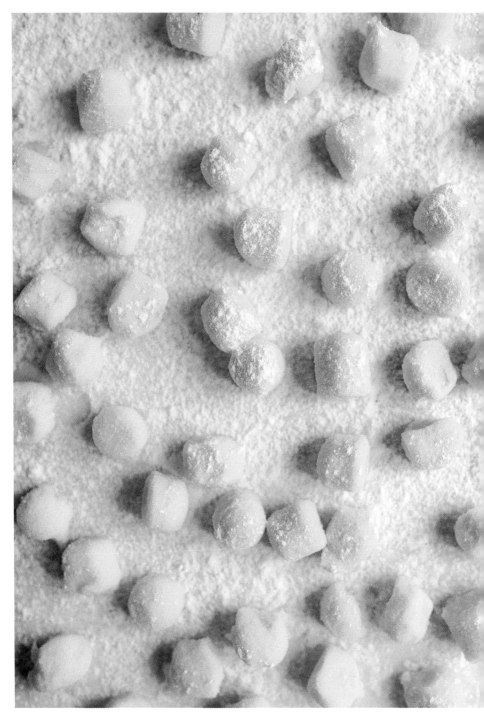

eggs [5]
cooked spaghetti 3 ¾ cups
grated parmesan ½ cup
grated pecorino romano ⅓ cup
milk ¼ cup olive oil 1 tablespoon
garlic 1 clove

[1] In a large bowl, beat the eggs. Add the cooked pasta and the cheeses. Season with pepper and toss well to combine. Add milk to moisten the mixture.

[2] In a large, nonstick pan, heat the oil over medium heat. Add a barely crushed garlic clove, and infuse 1 minute over low heat before removing.

[3] Pour the pasta mixture into the pan. Cook 8 minutes over low heat. Slide the frittata out onto a plate, then cover the plate with the pan, and turn the frittata back into the pan so that it can cook on the other side. Cook 8 minutes more.

[4] Serve hot or cold.

Recipe by chef Lorenza Lenzi.

Serves 4 Preparation 10 min Cooking 17 min

Spaghetti Frittata

240

vegetarian dashi 1 cup (see recipe p. 161)

olive oil 2 tablespoons clams 1 pound 1 ounce

sake ⅔ cup garlic 1 clove

fregola sarda 1 ½ cups

tomato coulis 1 cup

parsley 3 sprigs sea urchin 4

[1] Prepare the vegetarian dashi (see recipe p. 161).

[2] In a pot, heat 1 tablespoon of olive oil over medium heat. Add the clams and the sake, then cover and cook until the clams open. Remove the clams with a slotted spoon, and set aside at room temperature. Discard any clams that don't open. Strain and reserve the cooking liquid.

[3] Chop the garlic. In a large pot, heat the garlic in 1 tablespoon of olive oil, then add the fregola sarda and cook for a few minutes. Add the clam cooking liquid, ⅓ of the dashi, and the tomato coulis. Stir to combine, and add dashi whenever the mixture becomes dry. Cook 10 minutes, then remove from the heat.

[4] Chop the parsley and add it, along with the clams and sea urchins, to the fregola. Cover and rest 5 minutes before serving.

Serves 2 Preparation 10 min Cooking 35 to 40 min

Fregola Sarda alle Vongole

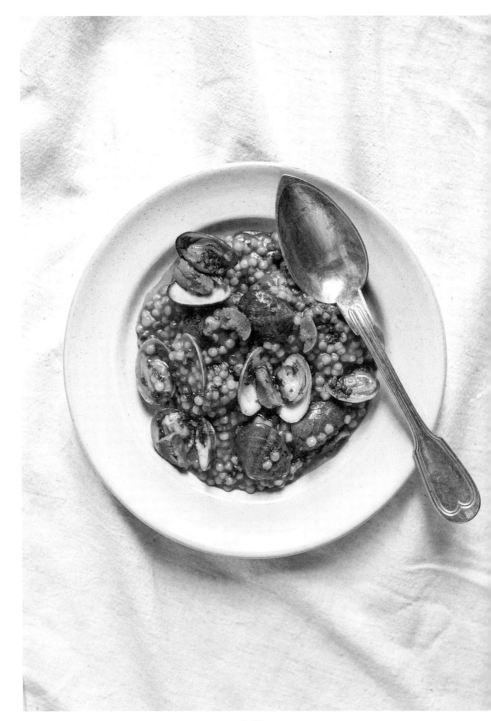

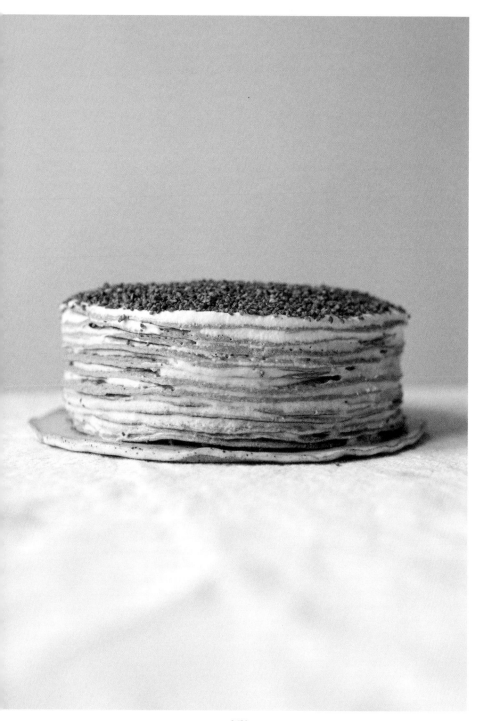

vanilla ^{1 bean pod} egg ¹
buckwheat flour ^{1 ¾ cups}
skim milk ^{1 ¼ cups} egg whites ²
baking powder ^{2 teaspoons} salt ^{1 pinch}

Chestnut cream

heavy cream ^{2 ½ cups}
chestnut paste ^{5 ⅓ ounces}

sunflower oil
roasted buckwheat

Make the batter

[1] Split the vanilla bean pod lengthwise, scrape out the seeds with the edge of a knife, and place in a mixing bowl. In the same bowl, whisk the vanilla seeds, egg, buckwheat flour, skim milk, egg whites, baking powder, and salt with ¾ cup + 1 ½ tablespoons water until smooth. Rest 1 hour at room temperature.

Make the chestnut cream

[2] Beat the heavy cream with a whisk or beater to stiff peaks, then carefully fold in the chestnut paste with a rubber spatula.

[3] Heat a nonstick pan and add a drop of oil. Add a ladleful of crêpe batter, and cook on each side until golden. Cook a dozen crêpes in this way, then set aside to cool.

[4] Place a first crêpe on a serving dish, and spread a ⅓-inch-thick layer of chestnut cream over the top. Cover with a second crêpe. Repeat for each crêpe, finishing with a layer of chestnut cream. Sprinkle with roasted buckwheat. Chill the crêpe cake for at least 1 hour before serving.

Serves 6 Preparation 30 min Cooking 15 min Rest 2 hours

Buckwheat Mille Crepe Cake

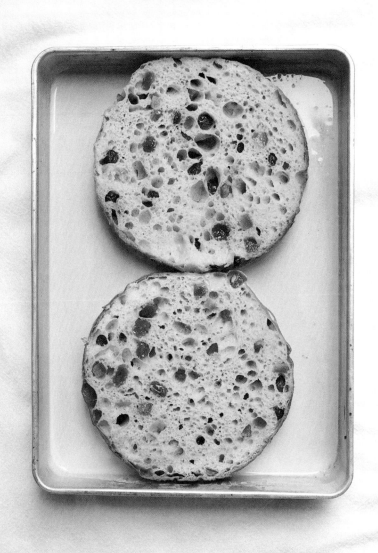

panettone ^{4 slices}

eggs ³ sugar ^{⅓ cup} milk ^{1 cup}

orange blossom water ^{1 teaspoon}

vanilla ^{1 bean pod}

raw cane sugar ^{3 tablespoons}

butter ^{1 ½ tablespoons}

heavy cream ^{7 tablespoons}

[1] Arrange the slices of panettone in a baking dish.

[2] In a bowl, beat the eggs with the sugar, milk, and orange blossom water.
Split the vanilla bean pod lengthwise and scrape out the seeds with the
edge of a knife. Add the seeds and the bean pod to the mixture. Pour the
mixture over the panettone, and rest overnight in the fridge.

[3] Preheat the oven to 340ºF.

[4] Place the panettone slices on a rack and cube the butter. Sprinkle the
slices with raw cane sugar, and add the cubed butter on each slice.

[5] Place the panettone slices on a baking sheet lined with parchment paper.
Bake 8 to 10 minutes, until golden brown.

[6] Whip the cream until light and fluffy, and serve with the hot panettone
French toast.

Serves 4 Preparation 10 min Cooking 10 min Rest 1 night

Panettone French Toast

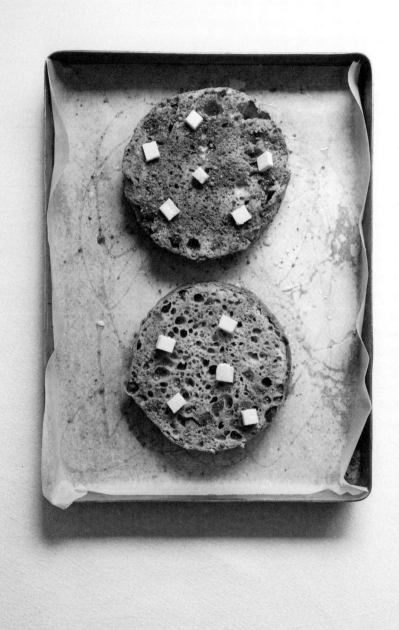

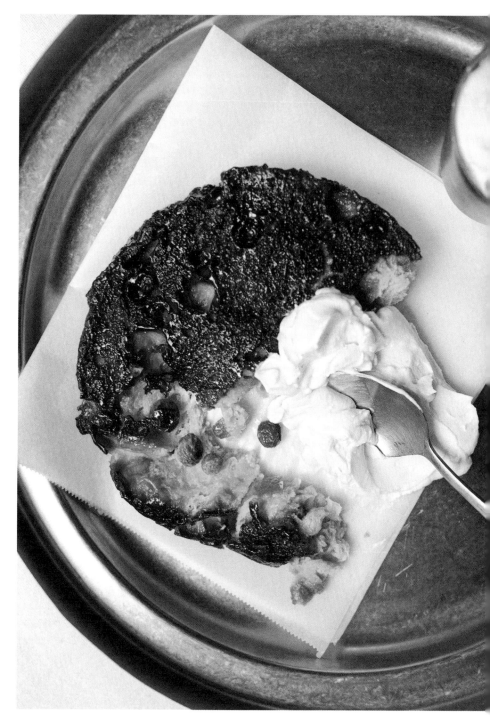

Coffee Syrup

coffee (Vietnamese preferred) 7 tablespoons
sugar ½ cup

Panna Cotta

gelatin 3 leaves
sweetened condensed
milk 1 (14-ounce) can
heavy cream ¾ cup + 1 ½ tablespoons

Make the coffee syrup
[1] Brew the coffee in advance.
[2] In a small saucepan, bring the coffee and sugar to a boil. Cook for
 3 minutes, then set aside to cool completely.

Make the panna cotta
[3] Soften the gelatin leaves in cold water.
[4] In a saucepan, combine the condensed milk and an equal volume of
 water (use the can to measure). Add the cream, and heat the mixture for
 3 minutes. Once it comes to a boil, remove from the heat.
[5] Squeeze the water from the gelatin leaves, and add them to the cream
 mixture. Stir to combine. Pour the mixture into 6 cups, and chill
 3 hours.
[6] Just before serving, pour a bit of the coffee syrup over the panna cotta.

Serves 6 Preparation 10 min Cooking 10 min Rest 3 hours

Vietnamese
Coffee Panna Cotta

Chocolate cake

butter $^{1\,1/4\ \text{sticks}}$

dark chocolate $^{7\ \text{ounces}}$

raw cane sugar $^{1/4\ \text{cup}}$ eggs 3

baking powder $^{1/2\ \text{teaspoon}}$

cornstarch $^{1/2\ \text{cup}}$ fleur de sel $^{2\ \text{pinches}}$

——————

Meringue

egg whites 2 powdered

sugar $^{1\,1/3\ \text{cups}}$ cornstarch $^{1\ \text{tablespoon}}$

unsweetened cocoa

powder $^{2\ \text{tablespoons}\ +\ 2\ \text{teaspoons}}$

——————

Make the chocolate cake

[1] Let the butter soften at room temperature. Preheat the oven to 320°F.
 Melt the chocolate in a double boiler.

[2] In a mixing bowl, whisk together the butter and the cane sugar. Add the
 eggs, one by one, whisking between each addition. Add the cornstarch,
 baking powder, and fleur de sel.

[3] Incorporate the melted chocolate and mix until smooth. Pour the batter
 into a buttered cake pan and bake 18 minutes.

Make the meringue

[4] In a bowl, beat the egg whites until light and fluffy, then beat in the
 powdered sugar in three additions. Once the meringue is quite firm, add
 the cocoa and the cornstarch. Whisk until smooth.

[5] Remove the cake from the oven, and use a spatula to spread the
 meringue mixture over the top. Return to the oven and bake 18 minutes
 more. Set aside to chill before unmolding.

Serves 4 Preparation 15 min Cooking 45 min

Chocolate Meringue Cake

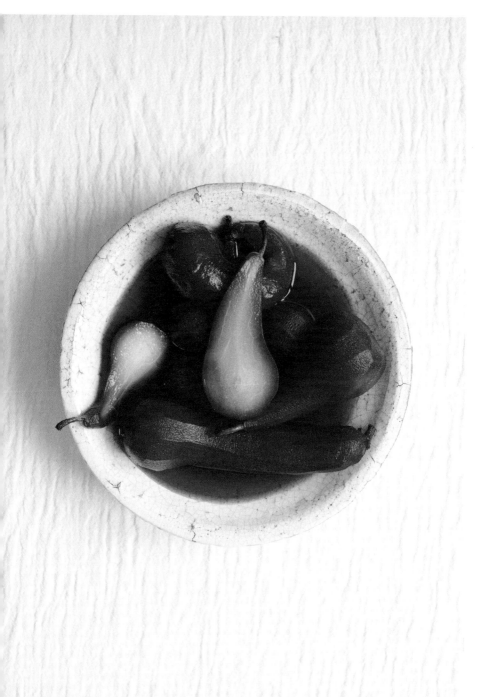

sweet vermouth $^{2\ \frac{1}{8}\ \text{cups}}$
sugar $^{\frac{1}{2}\ \text{cup}}$ honey $^{2\ \text{tablespoons} + 1\ \text{teaspoon}}$
pears 6 lemon $^{\frac{1}{2}}$

[1] Combine 2 ⅛ cups water and the vermouth in a saucepan, and add the sugar and honey. Bring to a boil over low heat.

[2] Peel the pears, leaving the stem intact. Drizzle with lemon juice and rub with the lemons as you go to keep the pears from oxidizing.

[3] As soon as the syrup comes to a boil, add the pears and cook at a simmer for 15 to 20 minutes, turning gently from time to time.

[4] Remove the pot from the heat, and set the pears aside to cool in the syrup at room temperature.

[5] Serve the pears, whole or halved in two, on plates, drizzled with the syrup.

Serves 6 Preparation 10 min Cooking 25 min

Pears with Vermouth

almonds $^{1/3 \text{ cup}}$
peaches 3 honey $^{3 \text{ tablespoons}}$
mineral water $^{4 \, 1/4 \text{ cups}}$
white tea $^{2 \text{ teaspoons}}$ lemon $^{1/2}$

———

[1] Halve the almonds, pit the peaches and roughly chop them.
[2] Place in a saucepan with the honey and the water, and heat for 15 minutes over low heat. Remove from the heat.
[3] Off the heat, add the tea and infuse 8 minutes.
[4] Strain the mixture through a fine-mesh sieve into a pitcher, set aside to cool, then chill.
[5] Enjoy the iced tea with a drizzle of lemon juice.

Makes 4 ¼ cups Preparation 10 min Cooking 15 min
Iced White Tea with Peach and Almond

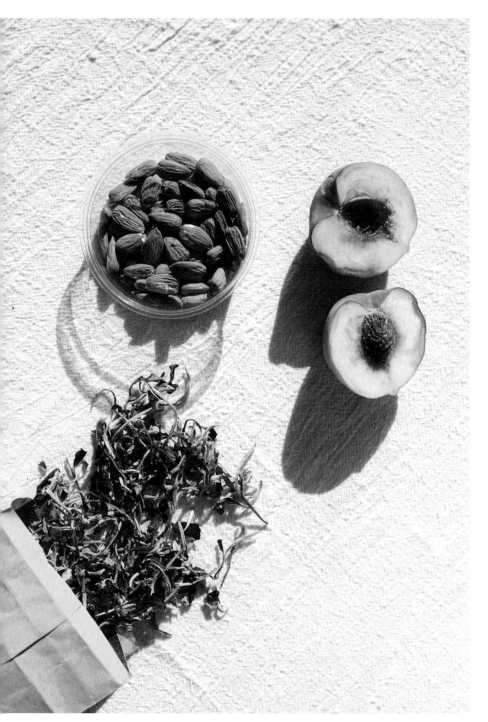

canned chickpeas ^{3 ¼ cups}
dried verbena ^{2 tablespoons}
sugar ^{2 tablespoons}
dark chocolate ^{3 ½ ounces}

[1] Drain the canned chickpeas and strain the liquid into a mixing bowl. Reserve the chickpeas for another recipe (Harira, see recipe p. 219).

[2] In a saucepan heat ¾ cup water. Then, remove from the heat.

[3] Off the heat, add the verbena and infuse 20 minutes.

[4] Melt the chocolate over a double boiler. Remove from the heat and add the verbena infusion.

[5] Beat ⅔ cup of the chickpea liquid with a beater until stiff peaks, as with egg whites. Add the sugar gradually, then gently fold in the verbena-infused chocolate with a rubber spatula.

[6] Transfer the mousse to a 4 soup plate, and chill at least 2 hours before serving.

Serves 4 Preparation 35 min Rest 2 hours
Chocolate Verbena Aquafaba Mousse

Miso Custard

egg yolks [4]

sugar ⅓ cup white miso 1 tablespoon

whole milk 2 ⅛ cups

Meringue

egg whites [4] salt 1 pinch

superfine sugar ⅓ cup + 1 ¾ tablespoons

Miso Caramel

brown sugar 2 tablespoons + 2 teaspoons

sugar 2 ½ tablespoons

heavy cream 4 tablespoons

red miso 1 teaspoon

butter ¾ tablespoon

sunflower oil

Serves 2 Preparation 30 min Cooking 30 min

Miso Floating Island

Make the miso custard
[1] Separate the eggs, and reserve the whites for the meringue. In a mixing
 bowl, beat the egg yolks with the sugar and the white miso.
[2] Heat the milk in a saucepan until simmering. Pour immediately over the
 egg yolk mixture, and mix well to combine.
[3] Transfer the mixture to the same saucepan, and cook over low heat,
 mixing all the while, until a thick cream forms.

Make the meringue
[4] Beat the reserved egg whites with a pinch of salt, and add the sugar a
 third at a time.
[5] Grease with the oil a heat-safe bowl about 5 inches in diameter, and
 transfer the beaten egg whites into it. Bake in a bain marie for 10 minutes
 at 325°F. Unmold into a shallow bowl or soup plate and set aside.

Make the miso caramel
[6] In a saucepan, heat the sugars with 2 tablespoons + 1 teaspoon water
 over high heat, until they take on a lovely caramel color.
[7] Remove from the heat, then add the cream, miso, and the butter.
 Mix to combine.
[8] Unmold the meringue on a serving dish. Pour the custard and then
 the caramel over the meringue, and serve.

Serves 2 Preparation 30 min Cooking 30 min

Miso Floating Island

almonds ^{1 ½ cups}

dried dates ^{3 ½ ounces (about 12 to 14)}

honey ^{1 tablespoon}

orange flower water ^{1 teaspoon}

mineral water ^{4 ¼ cups}

———

[1] The night before, soak the almonds in 4 ¼ cups water. Set aside to rest at room temperature overnight.

[2] The next day, pit the dates. Place them in a blender with the drained almonds, honey, orange flower water, and mineral water. Blend 5 minutes at maximum speed.

[3] Strain the almond milk through a cheesecloth and funnel over a glass bottle. Store in the fridge until ready to use.

Almond milk can be enjoyed on its own or used in cooking, such as in desserts (Blancmange, see recipe p. 305).

Makes 4 ¼ cups Preparation 10 min Rest 1 night Keeps 1 week

Almond Milk

Dough

active dry yeast [2 teaspoons]
sugar [½ cup] butter [3 ½ tablespoons]
egg [1] coconut milk [½ cup]
pastry flour [4 cups]

Jasmine syrup

sugar [1 cup]
jasmine flower buds [1 ounce]

frying oil

Makes 25 loukoumades (serves 4)
Preparation 10 min Cooking 5 min Rest 2 hours

Jasmine Syrup
Loukoumades

Make the dough

[1] Dissolve the active dry yeast in 7 tablespoons of warm water with
 1 tablespoon of sugar, and set aside for 10 minutes.
[2] Melt the butter in a saucepan.
[3] Beat the egg in a mixing bowl. Add the remaining sugar, melted butter,
 and coconut milk. Add half the flour and mix. Then, slowly incorporate
 the rest of the flour until a smooth dough forms. Knead 10 minutes
 vigorously, then cover and rest in a warm place for 1 ½ hours.
[4] On a lightly floured work surface, divide the dough into three equal
 balls. Divide each of the pieces into 1-ounce portions, and roll into balls.
 Arrange the balls on a baking sheet lined with parchment paper, cover,
 and rest in a warm place for 30 minutes.

Make the jasmine syrup

[5] In a saucepan, heat 1 cup of water, and dissolve the sugar in it. Reduce for
 a few minutes, then remove from the heat.
[6] Off the heat, add the jasmine flowers, and infuse until the syrup
 has cooled.
[7] In a heavy-bottomed pot, heat the oil to 340°F. Fry the loukoumades
 for 1 to 2 minutes per side, until they are golden brown. Drain. Serve the
 loukoumades drizzled with jasmine syrup and serve with tea.

Makes 25 loukoumades (serves 4)
Preparation 10 min Cooking 5 min Rest 2 hours

Jasmine Syrup
Loukoumades

Doughnuts

butter [4 ¼ tablespoons] milk [1 cup]
vanilla extract [1 teaspoon] sugar [⅓ cup]
eggs [2] salt [1 pinch] flour [4 cups]
active dry yeast [2 ½ teaspoons]

Saffron and rose glaze

milk [6 tablespoons] rose water [1 teaspoon]
powdered sugar [4 cups + 6 tablespoons]
saffron [20 threads] frying oil

Make the doughnuts

[1] In a saucepan, melt the butter in the milk. Set aside to cool, then transfer to a mixing bowl. Add the vanilla, sugar, eggs, salt, and yeast, and mix well to combine. Slowly incorporate the flour into the mixture until you have a soft dough that is no longer sticky. Cover with a dish towel, and set aside at room temperature to proof for 1 to 1 ½ hours.

[2] Punch the dough down and roll it out on a floured work surface to between ⅓ and ½ inch in thickness. Using a 4-inch cookie cutter, cut out rounds, and cut smaller rounds in the middle. Arrange the doughnuts on a floured work surface. Cover with a dish towel, and rest 30 minutes.

Make the glaze

[3] Heat the milk, then add the rose water. Off the heat, infuse the saffron in the milk for 1 hour.

[4] Incorporate the powdered sugar into the mixture, stirring until smooth.

[5] In a heavy-bottomed pot, heat the oil to 350°F over medium heat. Fry the doughnuts until golden brown on both sides. Drain.

[6] Dip one side of each doughnut into the glaze, and set aside on a rack to dry. Garnish with a few threads of saffron. Wait until the glaze is totally dry.

Makes 10 doughnuts Preparation 20 min
Cooking 10 min Rest 2 hours 30 min to 3 hours

Saffron and Rose Doughnuts

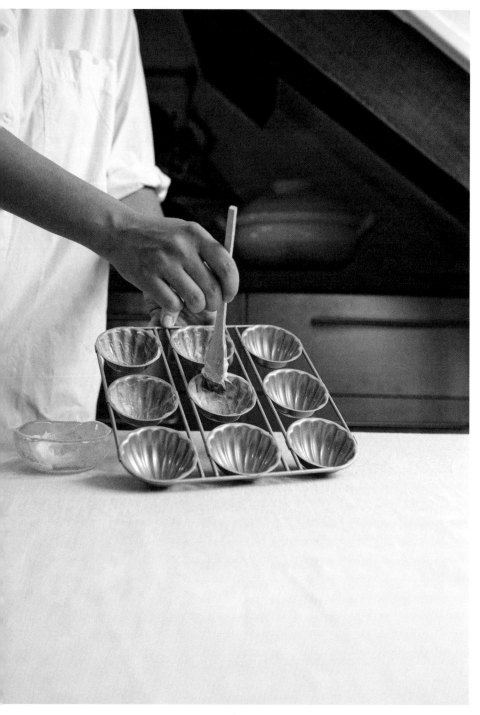

butter 11 ½ tablespoons plus more for greasing

pastry flour 1 ½ cups plus more for dusting

vanilla 1 bean pod

eggs 3 sugar ½ cup

honey 3 tablespoons + 1 teaspoon

baking powder 2 teaspoons

[1] Butter and flour the madeleine molds, then chill while you make the batter.

[2] Preheat the oven to its highest temperature.

[3] In a saucepan, melt the rest of the butter. Split the vanilla bean pod lengthwise and scrape out the seeds with the edge of a knife. Reserve the pod for another use.

[4] Beat the eggs with the sugar, honey, and scraped vanilla seeds, then stir in the flour, baking powder, and melted butter. Transfer the batter to a piping bag and chill at least 2 hours.

[5] Remove the batter from the fridge and fill the madeleine mold. Chill 10 minutes.

[6] Turn off the oven and immediately place the mold into the oven. Leave 10 minutes, and then, without opening the door, turn the oven back on to 350ºF and continue baking 2 minutes more.

[7] Remove the madeleines from the oven and unmold immediately.

Serves 2 (makes 10 to 15 madeleines) Preparation 15 min
Cooking 12 min Rest 2 hours 10 min

Honey Madeleines

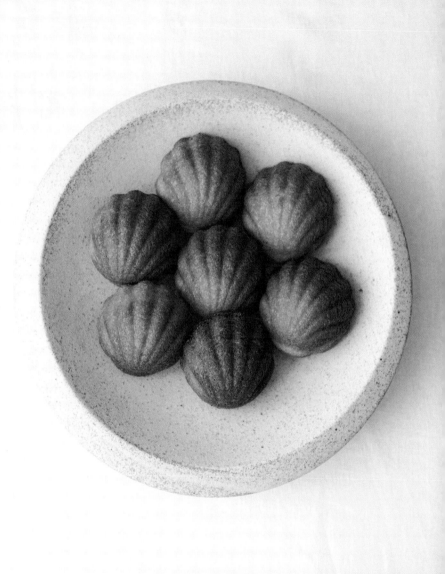

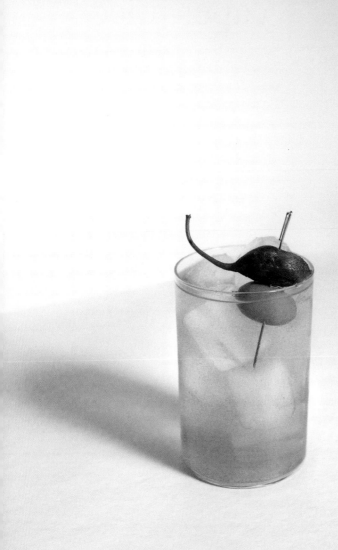

gin $^{1\,1/3\text{ ounces}}$ caper juice $^{1\text{ teaspoon}}$
lemon 1 tonic $^{2\,3/4\text{ to }4\,3/4\text{ ounces}}$
caper berry 1

[1] In a glass, combine the gin, caper juice, and juice of the lemon. Add ice cubes and the tonic, and stir.

[2] Garnish with a caper berry just before serving.

Makes 1 Preparation 5 min

Dirty Gin Tonic

almonds ^{1 ⅛ cups}
argan oil ^{6 ¾ tablespoons}
honey ^{7 tablespoons}

———

[1] Place the almonds in a baking dish. Toast for 15 minutes at 375ºF.
[2] Transfer the almonds to a food processor with the argan oil and
 the honey. Process at high speed until smooth. Add water as needed.
[3] Store the amlou in the resealable jar.

Amlou can be enjoyed on toast, stirred into yogurt, or on crêpes.

For 1 (12-ounce) hermetically sealed glass jar
Preparation 45 min Storage 1 month

Amlou

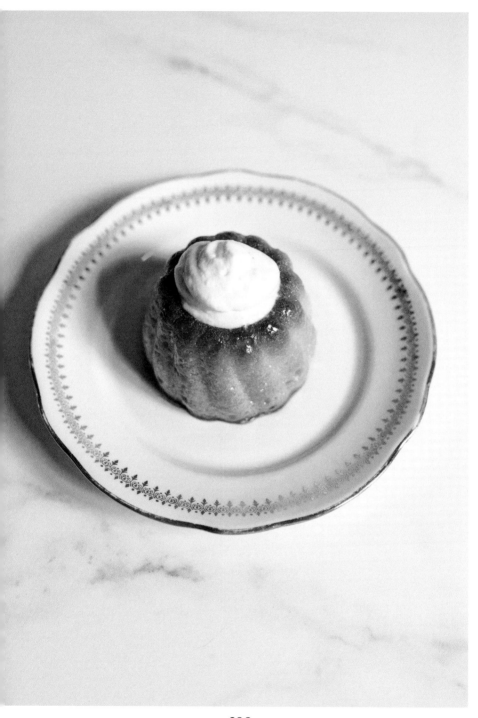

Dough

active dry yeast ^{3 ½ teaspoons}

milk ^{1 ½ teaspoons}

butter ^{4 ¼ tablespoons} pastry flour ^{1 ⅔ cups}

sugar ^{1 tablespoon + 2 teaspoons}

salt ^{¾ teaspoon} eggs ^{2 extra-large}

———

Whipped cream

vanilla ^{1 bean pod}

heavy cream ^{1 ¼ cups}

powdered sugar ^{1 tablespoone}

———

Cognac syrup

sugar ^{1 cup} cognac ^{½ cup}

citrus ^{1 zest (optional)}

———

For 4 small baba molds or 1 large one

Preparation 20 min Cooking 40 to 50 min Rest 1 hour 15 min

Baba au Cognac

Make the dough
[1] Dissolve the yeast in warmed milk. Remove the butter from the fridge so
 that it is at room temperature.
[2] Knead the flour, sugar, salt, and yeast together in a mixer. Incorporate
 the eggs, and knead until the dough comes away from the sides of
 the mixer. Next, incorporate the softened butter a third at a time,
 kneading until the dough is elastic.
[3] Cover the dough with a dish towel and allow to proof for 45 minutes
 at room temperature.
[4] Butter the mold or molds and transfer the dough into them, filling about
 two-third of the way. Set aside to proof once more for 30 minutes.
[5] Preheat the oven to 350°F for 10 minutes.
[6] Bake 20 minutes for individual molds or 30 minutes for a large one.

Make the whipped cream
[7] Split the vanilla bean pod lengthwise and scrape out the seeds with
 the edge of a knife. Whip the cream with the vanilla and sugar until light
 and fluffy.

Make the cognac syrup
[8] In a saucepan, heat 2 ¼ cups water and sugar over low heat.
[9] Remove from the heat and add cognac and the citrus zest, if using.
 Set aside to cool.
[10] Remove the baba (or babas) from the mold, place on a rack, and soak in
 the syrup until spongy. Place them on a dish and cover with whipped
 cream.

For 4 small baba molds or 1 large one
Preparation 20 min Cooking 40 to 50 min Rest 1 hour 15 min

Baba au Cognac

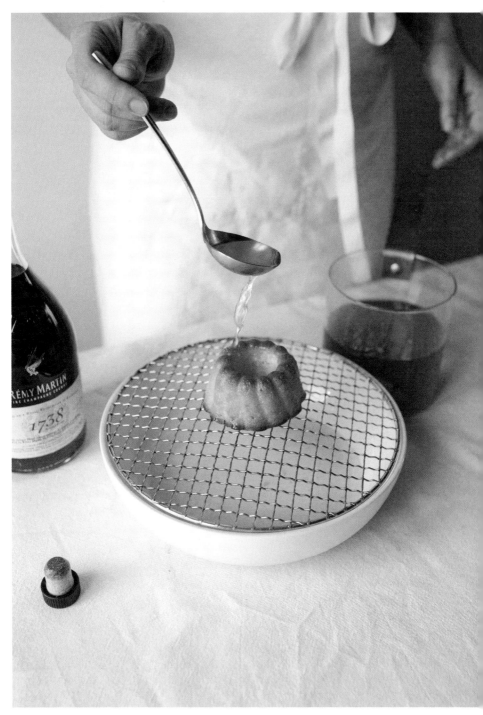

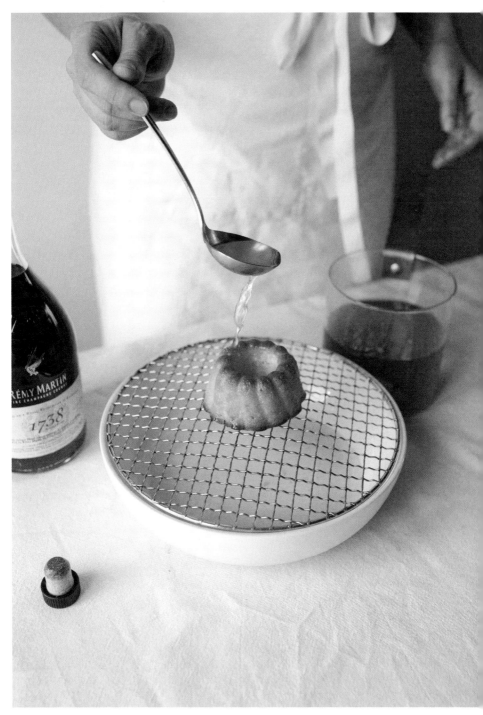

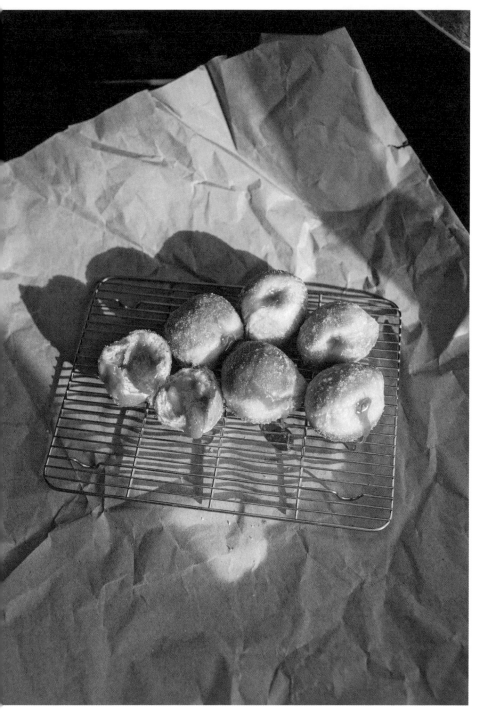

Maple caramel

maple syrup ¾ cup
heavy cream ½ cup
butter 4 ¼ tablespoons

———

Dough

active dry yeast 1 tablespoon
whole milk 1 ¼ cups
pastry flour 4 ¾ cups egg 1
sugar 3 tablespoons + 1 teaspoon
plus more for rolling
vanilla extract ¼ teaspoon
salt ½ teaspoon butter 3 tablespoons

———

frying oil

———

Makes 8 to 10 doughnuts
Preparation 15 min Cooking 10 min Rest 3 hours

Maple Caramel Doughnuts

Make the maple caramel
[1] Heat the maple syrup in a saucepan, and bring to a boil (or about 350°F).
[2] Heat the cream in a separate saucepan.
[3] Add the cream to the syrup bit by bit, emulsifying with a whisk. Add
 diced butter bit by bit, mixing all the while. Set the caramel aside to cool
 before transferring to a piping bag.

Make the dough
[4] Dissolve the yeast in warm milk.
[5] Combine the pastry flour, egg, sugar, vanilla extract, salt, butter, and
 dissolved yeast and milk mixture. Knead on a floured work surface for
 10 minutes. Form a dough ball, cover with a dish towel, and set aside to
 rise at room temperature for an hour, or until it doubles in volume.
[6] Punch the dough down and knead once more for about 2 minutes. Cover,
 and set aside to rise a second time for 30 minutes.
[7] Using a rolling pin, roll out the dough ⅛ inch thick. Cut out rounds
 2 inches in diameter.
[8] Arrange the dough rounds on a floured baking sheet and cover with
 a dish towel. Set aside at room temperature to rise until doubled in size.
 You will need about 2 hours from the first proof to this last one.
[9] Heat the oil in a large pot over medium heat. Cook the dough rounds for
 about 5 minutes per side, or until golden brown.
[10] Drain the doughnuts, then toss in sugar.
[11] Using the end of the piping bag, make a hole in each of the doughnuts.
 Fill with the maple caramel and serve immediately.

Makes 8 to 10 doughnuts
Preparation 15 min Cooking 10 min Rest 3 hours
Maple Caramel Doughnuts

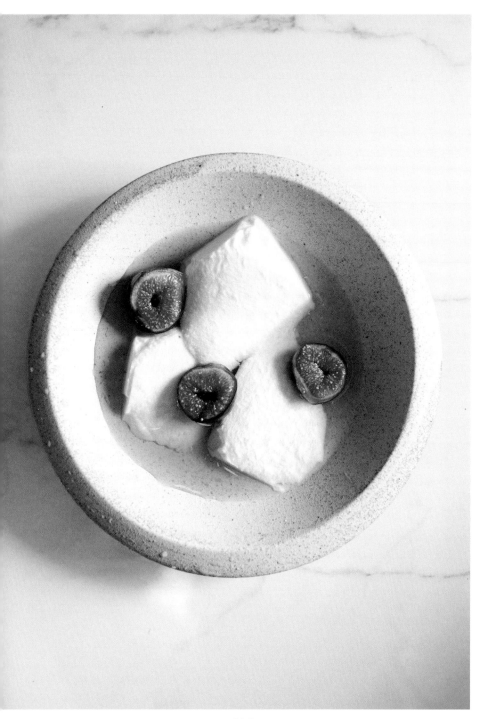

Blancmange

almond milk $^{2\ 1/8\ cups}$

honey $^{2\ tablespoons}$ agar-agar $^{1/2\ teaspoon}$

Fig syrup

sugar $^{1/2\ cup}$ figs 4

rose water $^{1\ teaspoon}$

edible rosebuds $^{10\ (optional)}$

Make the blancmange

[1] In a saucepan, combine the almond milk (see recipe p. 277), honey, and agar-agar, and bring to a boil. Remove from the heat and pour the mixture into a shallow dish. Set aside to cool, then chill 4 hours.

Make the fig syrup

[2] In a saucepan, dissolve the sugar in 2 ⅛ cups water, then bring to a boil for 5 minutes. Remove from the heat.

[3] Off the heat, add halved figs, rose water, and rosebuds, if using. Set aside to cool completely.

[4] Cut the blancmange into pieces and lay on a serving dish. Drizzle with the fig syrup and serve.

Serves 2 Preparation 15 min Rest 4 hours

Almond Milk and Fig Syrup Blancmange

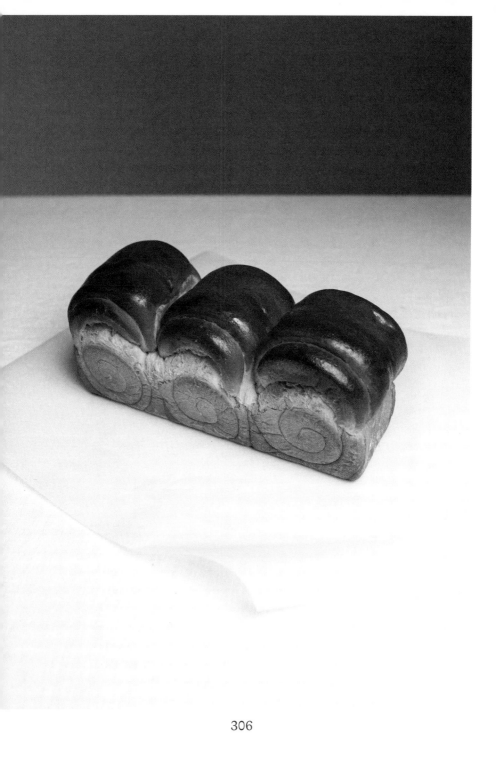

Tangzhong
(make 6 ¾ ounces)

pastry flour ¼ cup

milk ⅔ cup

———

Dough

eggs 2 sugar 7 tablespoons

pastry flour 4 ¾ cups + 2 tablespoons
plus more for dusting

heavy cream 4 tablespoons

milk powder 1 tablespoon

tangzhong 6 ¾ ounces salt 1 ½ teaspoons

active dry yeast 4 teaspoons

butter 3 ½ tablespoons

———

egg yolk 1

———

Serves 4 Preparation 20 min Cooking 40 min Rest 1 hour 30

Hokkaido Milk Bread

Make the tangzhong

[1] To make this rising agent that will make the dough tender and more elastic, combine the flour and the milk in a saucepan. Heat until the mixture thickens, or until it reaches 150°F. When the whisk leaves traces in its wake, the tangzhong is ready. Cover with plastic wrap to keep a skin from forming, and set aside to cool.

Make the dough

[2] In a bowl, beat the eggs with sugar. Add the flour, heavy cream, milk powder, and tangzhong. Add salt and yeast separately. Knead on a lightly floured work surface until the dough is smooth. Add cold, diced butter, and continue kneading for about 10 minutes, or until the dough is smooth and elastic. Roll the dough into a ball, cover and set aside to rise at room temperature for 40 minutes.

[3] On a lightly floured work surface, divide the dough into 6 even portions. Cover and rest 15 minutes more.

[4] Using a rolling pin, roll each of the dough balls out into an oval. Fold the left and right edges toward the center, then roll out once more and roll the dough on itself, as with a jelly roll. Place three dough balls into each baking dish, cover and set aside to rise 35 minutes.

[5] Preheat the oven to 350°F.

[6] Brush the tops of each dough ball with beaten egg yolk mixed with 1 teaspoon water. Bake 30 minutes, then unmold onto a rack and set aside to cool.

Serves 4 Preparation 20 min Cooking 40 min Rest 1 hour 30

Hokkaido Milk Bread

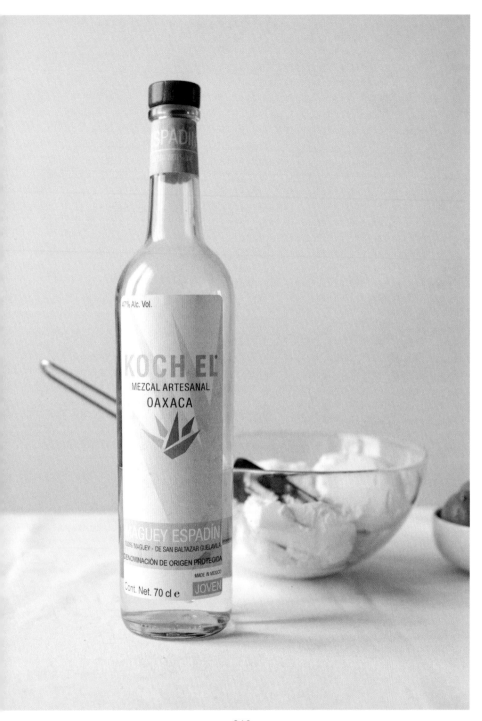

70% dark chocolate 1 bar

raw cream ¾ cup + 2 tablespoons

cream cheese 1 pound 5 ounces

mezcal 1 tablespoon cornstarch 2 tablespoons + 2 teaspoons

powdered sugar 1 cup

whole eggs 4 egg yolks 4

butter for greasing

[1] Preheat the oven to 400°F.

[2] Melt the chocolate in a double boiler, then set aside to cool slightly.

[3] Beat the raw cream, cream cheese, mezcal, cornstarch, and powdered sugar together in a mixing bowl. Add the whole eggs one at a time, mixing well after each addition. Add the egg yolks followed by the melted chocolate.

[4] Butter a 6-inch mold. Line with parchment paper, then pour in the cheesecake batter. Bake 20 minutes for a runnier cake, or 25 minutes for a firmer one.

[5] Chill the cheesecake overnight before unmolding and serving. Serve chilled or at room temperature for a runnier cheesecake.

Serves 2 Preparation 10 min Cooking 20 to 25 min Rest 1 night

Chocolate and Mezcal Cheesecake Brûlé

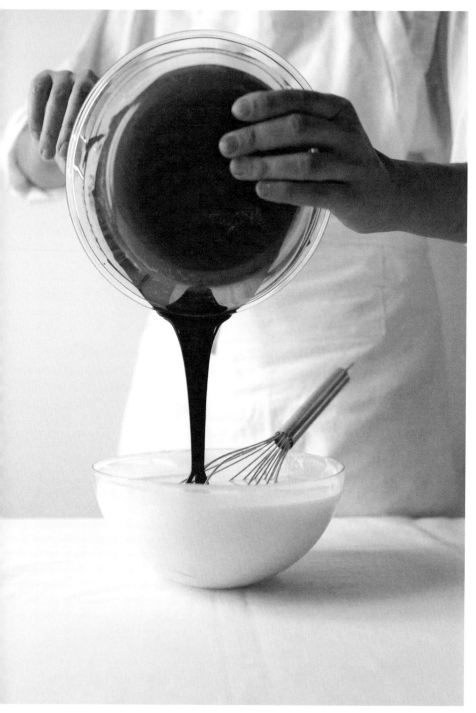

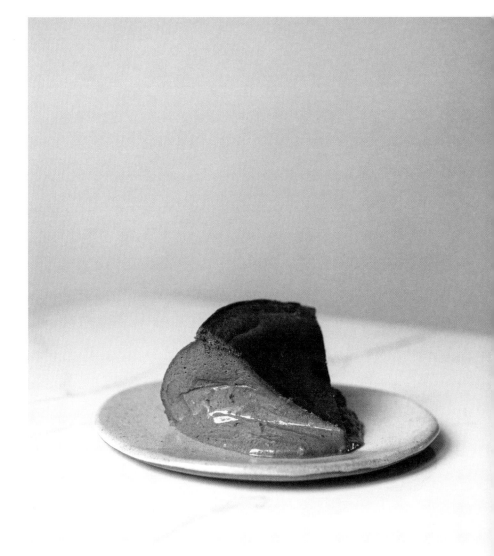

milk ½ cup sugar ⅓ cup
heavy cream ¾ cup + 1 ½ tablespoons
egg yolks 3 soy sauce 1 tablespoon
raw cane sugar 2 tablespoons

———

[1] Bring the milk to a boil in a saucepan, then remove from the heat.
[2] Off the heat, add the sugar and cream, and mix well to combine.
[3] Add the egg yolks, and cook over low heat, without boiling, for about
5 minutes. Add the soy sauce and mix to combine.
[4] Pour the mixture into two individual dishes or ramekins. Bake in a bain
marie for 35 minutes at 350ºF.
[5] Set aside to cool. Just before serving, sprinkle with cane sugar and brûler
with a kitchen blowtorch.

Serves 2 Preparation 10 min Cooking 40 min
Soy Sauce Crème Brûlée

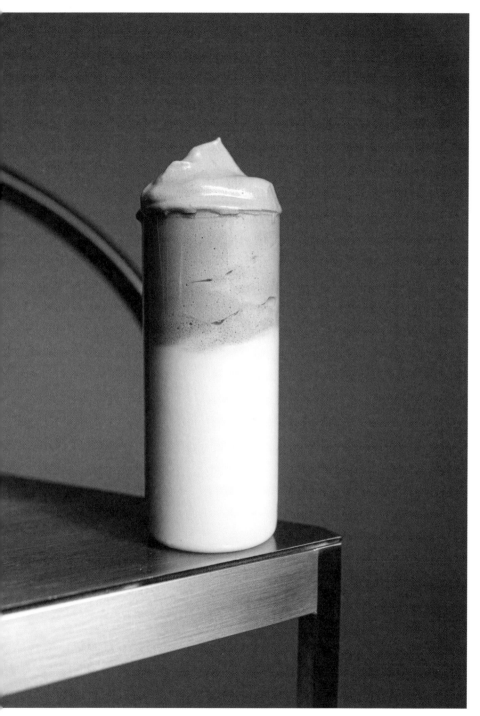

milk ^1 ⅔ cups rosebuds ^1 tablespoon
instant coffee ^2 ½ tablespoons
agave syrup ^2 tablespoons

[1] In a saucepan, bring the cold milk to a boil, then remove from the heat.
[2] Off the heat, add the rosebuds. Infuse until the milk has completely cooled.
[3] In a bowl, use an electric beater to beat 5 tablespoons of water with
 the coffee and agave syrup for about 10 minutes, or until nice and frothy.
[4] Strain the rose milk into a measuring cup and set aside.
[5] Pour the milk into two glasses. Top with a layer of coffee foam and serve
 immediately.

Serves 2 Preparation 20 min
Rose Dalgona Coffee

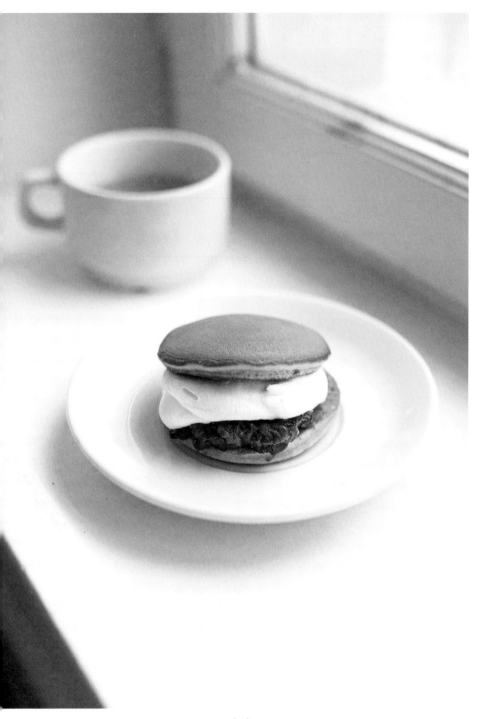

318

Black olive jam

vanilla $^{\text{1 bean pod}}$ lemon 1
pitted black olives $^{\text{⅓ cup}}$
raw cane sugar $^{\text{3 tablespoons}}$

Dough

eggs 4 sugar $^{\text{⅔ cup + 1 teaspoon}}$
honey $^{\text{2 teaspoons}}$ flour $^{\text{1 ¼ cups}}$
baking powder $^{\text{1 teaspoon}}$
sunflower oil $^{\text{2 tablespoons}}$

Ricotta Filling

butter $^{\text{2 teaspoons}}$ ricotta $^{\text{¼ cup}}$
sugar $^{\text{¼ cup}}$ egg 1
lemon zest
orange blossom water $^{\text{1 tablespoon}}$

Serves 4 Preparation 30 min Cooking 35 min

Ricotta and Black Olive Dorayaki

Make the black olive jam

[1] Split the vanilla bean pod lengthwise and scrape out the seeds with
 the edge of a knife. Reserve with the pod. Zest and juice the lemon,
 reserving the zest for the ricotta filling.
[2] Place the olives in a saucepan, and add water to cover. Bring to a boil and
 blanch 30 seconds. Drain and repeat.
[3] Roughly chop the olives.
[4] In the same, now-empty saucepan, add the lemon juice, raw cane sugar,
 and split vanilla bean pod. Add the chopped olives and stir to combine.
 Heat over medium heat until the sugar melts, then cook at a simmer for
 25 minutes.
[5] Set the jam aside to cool completely. Once cool, remove the vanilla bean pod.

Make the dough

[6] In a bowl, combine the eggs, sugar, and honey with a whisk. Sift in
 the flour and the baking powder, then knead until the batter is smooth.
[7] Chill the batter for 15 minutes; it should be thick yet runny, similar
 to pancake batter.
[8] Heat the sunflower oil in a pan over medium heat. Pour a small ladleful
 of dough into the pan and cook for 1 minute. While it cooks, the dough
 should spread out and rise all on its own. As soon as small bubbles appear
 on the surface, flip the dorayaki with a spatula. Continue until you have
 cooked all of the batter.

Make the ricotta filling

[9] Melt the butter.
[10] Combine the ricotta with the sugar in a mixing bowl. Add the egg,
 1 tablespoon of the reserved lemon zest, orange blossom water, and
 melted butter, and mix to combine.
[11] Spread the ricotta filling over one dorayaki, and spread the olive jam over
 another. Close like a sandwich.

Serves 4 Preparation 30 min Cooking 35 min

Ricotta and Black
Olive Dorayaki

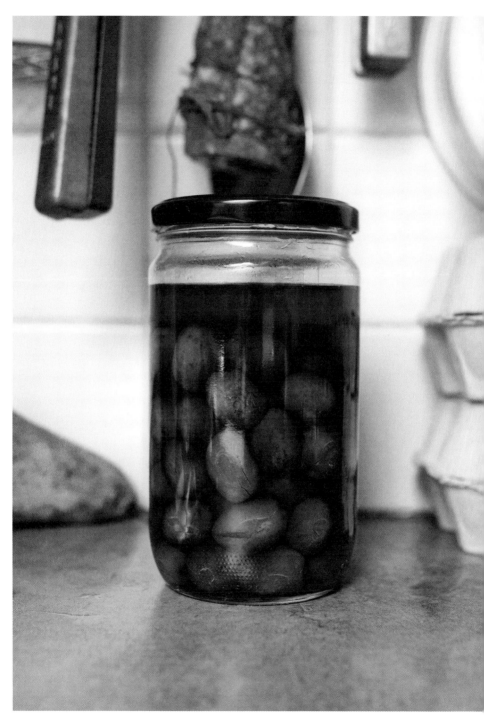

321

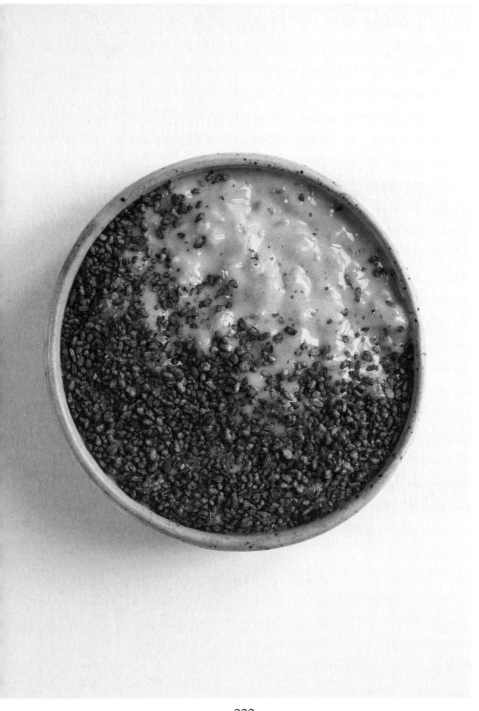

milk $^{2\ ¾\ cups}$ heavy cream $^{1\ ½\ cups}$ sobacha $^{3\ tablespoons}$ vanilla $^{2\ bean\ pods}$ sugar $^{½\ cup}$ short-grain rice $^{⅔\ cup}$

[1] Combine the milk, cream, and 2 tablespoons of sobacha in a saucepan. Heat for 20 minutes over medium heat. Strain over a measuring cup and return the resulting liquid to the pot.

[2] Split the vanilla bean pods and scrape the seeds out using a knife. Add the seeds and the split pods to the cream mixture.

[3] Add the sugar and rice to the cream. Bring to a boil, then reduce the heat to low and cook 35 to 40 minutes.

[4] Set aside to cool at room temperature for 20 minutes, then chill 1 hour minimum.

[5] Serve the rice pudding sprinkled with the remaining tablespoon of sobacha.

Serves 6 Preparation 10 min Cooking 1 hour Rest 1 hour 20 min

Rice Pudding with Sobacha

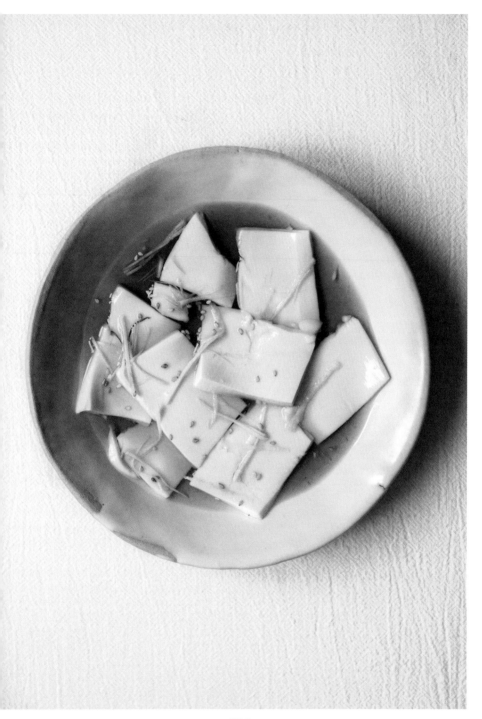

ginger [1 (⅖-inch) piece]
maple syrup [1 ¼ cups]
silken tofu [14 ounces]
sesame seeds [2 pinches]

[1] Peel the ginger and julienne. Set aside a bit for the garnish.

[2] In a saucepan, heat 7 tablespoons of water with the maple syrup. Add the ginger. Cook over low heat for 20 minutes, then set aside to cool.

[3] Thinly slice the tofu. Use a spoon to transfer slices to bowls. Drizzle with the syrup and garnish with the reserved ginger. Sprinkle with sesame seeds and serve.

Serves 2 Preparation 10 min Cooking 20 min
Maple-Ginger Tofu

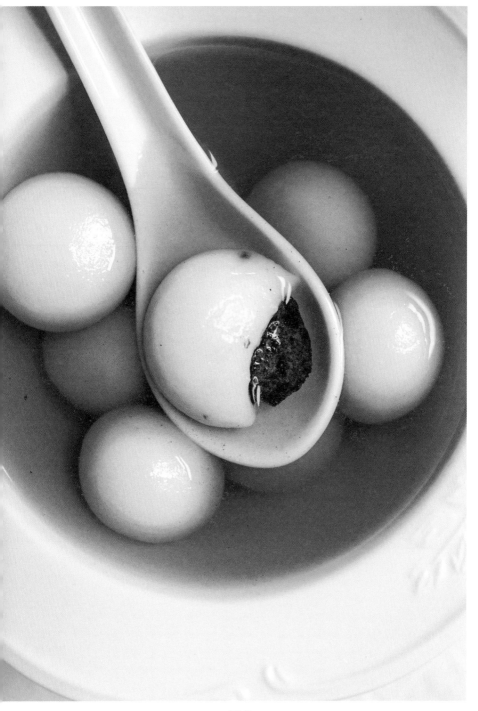

326

Filling
black sesame seeds $^{6\ tablespoons}$
white sesame seeds $^{2/3\ teaspoon}$
unsalted butter $^{2\ 1/2\ tablespoons}$
honey $^{2\ tablespoons}$

———

Dough
glutinous rice flour $^{3/4\ cup\ +\ 2\ 1/2\ tablespoons}$
rice flour $^{1/8\ cup}$

———

Syrup
ginger $^{1\ (4\text{-}inch)\ piece}$
palm sugar $^{1/4\ cup}$

———

Serves 6 (makes 20 yuan xiao) Preparation 30 min Cooking 30 min

Black Sesame Yuan Xiao

Make the filling

[1] In a dry pan, toast the black and white sesame seeds until golden. Set aside.

[2] Grind the sesame seeds into a fine black powder.

[3] In a saucepan, melt the butter. Add the sesame seed powder and mix well to combine.

[4] Incorporate the honey until you have a nice, smooth cream. Chill while you make the dough.

Make the dough

[5] In a bowl, combine the rice flours. Add 6 ¾ tablespoons of hot but not boiling water, and mix with chopsticks. Knead the dough by hand until soft, smooth, and no longer sticky. Form into a ball and wrap in plastic wrap. Set the dough aside to rest while you make the filling balls.

[6] Using a teaspoon, make small balls of filling of about 2 ½ teaspoons each. Roll into balls and set aside on a plate.

[7] Using a teaspoon, make small portions of dough about 1 ½ times the size of the filling balls. Roll the dough pieces into balls, then press into disks using your fingertips.

[8] Using chopsticks, place the filling balls on the dough disks, and wrap the dough around the filling, taking care not to stain the dough with the black sesame filling.

[9] Roll the yuan xiao between your palms to make nice, round balls.

Make the syrup

[10] Peel and julienne the ginger.

[11] In a saucepan, heat 2 ¼ cups water with the palm sugar and a few slices of ginger. Heat over low heat for 30 minutes.

[12] Bring 6 cups of water to a boil. Add the yuan xiao and cook for about 3 minutes, or until they come to the surface. Once they have begun to float, cook at a simmer for 2 minutes more. Transfer to a container of cold water to stop the cooking.

[13] Place the yuan xiao in a bowl and drizzle with syrup.

Serves 6 (makes 20 yuan xiao) Preparation 30 min Cooking 30 min

Black Sesame Yuan Xiao

Amlou: Moroccan almond and argan oil spread.

Aonori: green seaweed used in its dried form as a condiment in Japanese cuisine.

Banh Cuon Trung: steamed Vietnamese egg dumpling.

Banh Mi: Vietnamese baguette sandwich filled with meat, fermented vegetables (see do chua), fresh herbs, and chiles. Banh mi trung contains fried eggs, while banh mi ca moi is made with sardines.

Banh Mi Xiu Mai: type of banh mi made with meatballs and tomato sauce. The meatballs can either go in the baguette sandwich or be served on their own with sliced bread.

Hokkaido Milk Bread: enriched Japanese bread with a cloud-like texture.

Dalgona Coffee: South Korean drink made with milk and creamy coffee.

Chawanmushi: savory Japanese egg custard made with dashi and usually featuring gingko nuts, shrimp, or chicken.

Chilaquiles Rojos: Mexican dish of fried tortillas and tomato sauce typically served for breakfast.

Congee: rice porridge popular in China and Southeast Asia.

Massaman Curry: mild Thai curry.

Daikon: large Japanese white radish.

Dashi: Japanese broth made with kombu and dried bonito flakes. There is also a vegetarian version made with mushrooms. Dashi is used in the preparation of miso soup.

Do Chua: fermented vegetables typical of Vietnamese cuisine.

Dorayaki: a sort of Japanese pancake, typically served filled with red bean paste, like a sandwich.

Egg sando: Japanese sandwich made with white bread and egg. Sandos exist in both savory and sweet forms.

Masa Harina: typical Mexican flour made with corn that has been nixtamalized, or soaked and then cooked in an alkaline solution.

Kuzu Powder: starch similar to cornstarch made from the plant of the same name, used as a thickener and gelling agent in Japanese cuisine.

Guanciale: Italian cured meat specialty made with pork cheeks or jowls.

Inari Sushi: sushi made by filling fried tofu pockets with rice seasoned with vinegar and other ingredients.

Kabocha: Japanese squash variety.

Kabocha No Nimono: Japanese dish made by stewing kabocha squash in a sweet and savory broth.

Koji Rice: fermented rice used in Japanese cuisine to make shio koji, soy sauce, mirin, miso paste, and sake.

Loukoumades: tender Greco-Turkish doughnuts served with a sweet syrup.

Japanese Mayonnaise: slightly sweet, lemony mayonnaise.

Mirin: sweet sake used as a seasoning in Japanese cuisine.

Miso: fermented soy paste with a powerful, savory flavor. Miso paste is an essential ingredient in the Japanese soup of the same name.

White Miso (shiro miso): miso boasting the highest proportion of rice and lowest proportion of soy. This lightly fermented miso paste is also the mildest in flavor.

Red Miso (aka miso): rice or barley miso with a slightly longer fermentation time and thus a slightly more pronounced flavor.

Nitamago: Japanese marinated egg served in ramen.

Ochazuke: Japanese fish and rice dish over which tea is poured.

Okonomiyaki: sort of Japanese omelet cooked on a griddle (teppan) and traditionally filled with cabbage and vegetables and drizzled with okonomi sauce and Japanese mayonnaise.

Onsen Tamago: egg cooked low and slow. This traditional Japanese technique was once carried out in natural hot water springs (onsen).

Sake Kasu: lees resulting from the fermentation of sake. Sake kasu is used as a condiment in Japanese cooking.

Okonomi sauce: sweet Japanese sauce somewhat similar to Worcestershire sauce served on okonomiyaki (see above) or takoyaki (fried octopus-stuffed dough balls).

Shio Koji: traditional Japanese condiment made with fermented rice. It can replace salt or soy sauce as a seasoning.

Smen: fermented, salted butter hailing from North Africa.

Sobacha: toasted buckwheat groats used in Japanese cooking or infused as a tea.

Taimeshi: Japanese dish of rice and sea bream cooked in a broth.

Silken Tofu: tofu that has been neither drained nor pressed for a silky, flan-like texture.

Youtiao: Chinese fried dough served for breakfast. You tiao can also be served with congee.

Yuan Xiao: Chinese dessert not unlike Japanese mochi, made with rice balls filled with black sesame paste and served in a sweet syrup.

Glossary

Recipe Index

334

Ingredient Index

The Social Food
Home Cooking Inspired by the Flavors
of the World

First published in the United States
of America in 2022 by
Rizzoli International Publications, Inc.
300 Park Avenue South
New York, NY 10010
www.rizzoliusa.com

© 2022 The Social Food

Photography and Texts: Shirley Garrier
& Mathieu Zouhairi

Foreword: Julien Lô Dê Pham

Interior Layout Design: Syndicat
(Sacha Léopold & François Havegeer,
Léa Guillon)

Publisher: Charles Miers
Editorial Director: Catherine Bonifassi
Editor: Victorine Lamothe
Production Manager: Kaija Markoe
Managing Editor: Lynn Scrabis

Editorial Coordination:
CASSI EDITION
Vanessa Blondel, Candice Guillaume,
Emily Monaco, Tricia Levi

All rights reserved. No part of this
publication may be reproduced, stored
in a retrieval system, or transmitted
in any form or by any means, electronic,
mechanical, photocopying, recording,
or otherwise, without prior consent
of the publisher.

ISBN: 978-0-8478-7259-6
Library of Congress Control Number:
2022938265
2022 2023 2024 2025
/ 10 9 8 7 6 5 4 3 2 1
Printed in China

Visit us online:
Facebook.com/RizzoliNewYork
Twitter: @Rizzoli_Books
Instagram.com/RizzoliBooks
Pinterest.com/RizzoliBooks
Youtube.com/RizzoliNY
Issuu.com/Rizzoli